714ITAL ART

714ITAL ART

A COMPLETE GUIDE TO MAKING YOUR OWN COMPUTER ARTWORKS

David Cousens

Picture credits

All images by David Cousens, apart from the following: page 41 (bottom): Richard Rosenman; pages 66–71: photo by Marcus J. Ranum (model, Miss Mosh); page 72 (top): Corbis; page 78 (top left): illustration by Tim Shelbourne; pages 79–85: photo by Tigz Rice (model, Coco Dubois); pages 92–97: photo by Marcus J. Ranum.

Front cover: main image courtesy of *Digital Arts* magazine (http://www.digitalartsonline.co.uk); pages 52–53: gorilla image also courtesy of *Digital Arts* magazine.

The instructions in this book are given for Windows. The following conversions apply for Mac users:

Windows

Mac

Alt

Option

Crtl

Command

Right-click

Ctrl-click

This edition published in 2013 by Arcturus Publishing Limited 26/27 Bickels Yard, 151–153 Bermondsey Street, London SE1 3HA

Copyright © 2013 Arcturus Publishing Limited

All rights reserved. No part of this publication may be reproduced, stored in a retrieval system, or transmitted, in any form or by any means, electronic, mechanical, photocopying, recording or otherwise, without prior written permission in accordance with the provisions of the Copyright Act 1956 (as amended). Any person or persons who do any unauthorised act in relation to this publication may be liable to criminal prosecution and civil claims for damages.

ISBN: 978-1-84858-975-9

AD002486EN

Printed in Singapore

Contents

	Chapter One: Setting u	·	,
		RGB, CMYK and DPI	6
		Workspaces	8
		Pixels and Vectors	10
		Basic Non-Creative Tools	12
		Colour Selection	16
		Saving and Exporting in Different Formats	18
		Which Digital Art Program Is Right For You?	20
	Chapter Two: Creative		00
		The Pencil Tool and Aliased Pixels	22
		The Brush Tool	24
		Bristle Brushes and the Mixer Brush	26
		The Pen Tool	28
		The Eraser Tool	30
		The Custom Shape Tool	32
		The Type Tool	34
		The Free Transform Mode	36
		Blurs	38
		Filters	40
		Layer Masks	42
sensional .		Blending Modes	44
	Chapter Three: Creative		14
		Composition	46
		Leading the Eye	48
		Perspective	50 52
		Reflected and Ambient Light	54
		Establishing Mood with Colour	56
		Drawing Faces: Proportions	58
		Drawing Bodies	60
		Contrast	62
		Drawing Dynamic Poses	
		The Rule of Thirds	64
	Chapter Four: Digital A		66
		Retouching a Photo in Photoshop	72
		Oil Paint Effect	78
		Watercolour Cloning in Photoshop CS6	
		Silkscreen Print Effect	86 92
		Chalk and Charcoal Effect	92 98
		Highlights, Glows and Shadows	
		Drawing From Reference	106 112
		Creating Line Art From a Photo	
		Digital Distress Effects	120
		Retro Pixel Art	124
		Downloads/Index	128

Chapter One:

Setting Up

This chapter eases you into the world of digital art. It explains some of the terminology you will encounter, looks at the most commonly used tools, and guides you through the choices you will be presented with when you first start out.

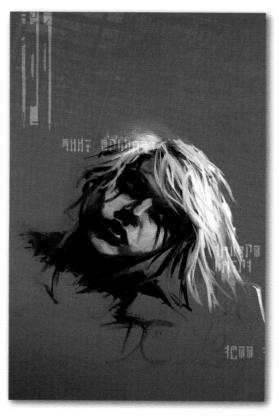

RGB, CMYK and DPI

When you create a new file you are presented with a number of choices about the options available. This can be a bit confusing for the uninitiated. Here is a beginner's guide to the various technical terms.

What is the difference between RGB and CMYK?

RGB (red, green. blue) and CMYK (cyan, magenta, yellow and key, or black) are the two main colour options available when you create a file. For screens and monitors emitting light, RGB is the most accurate way to display colours. CMYK is the best choice for physical formats, as printed pages absorb light.

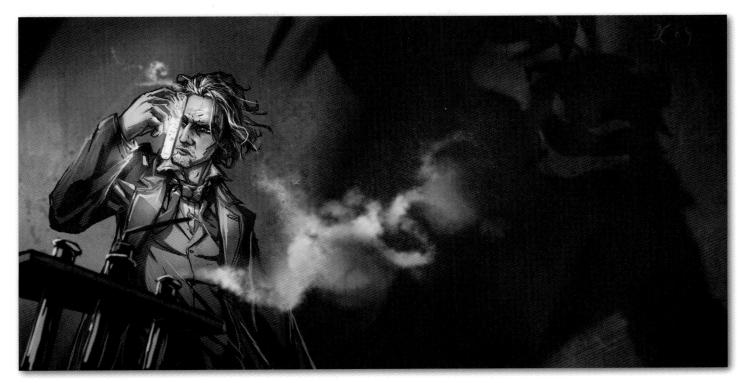

So which colour mode should you choose?

For RGB files, programs such as Photoshop have a lot more available options (including filters, layer styles and adjustment layers). It is therefore best to use this colour mode when painting. If you need to print an artwork, you can convert the file from RGB to CMYK when the image is finished.

Size matters!

DPI/PPI refers to the number of dots/pixels per inch – the density of dots in the image when it is reproduced either physically (printed on paper) or displayed on a monitor.

The native resolution of a computer screen is 72 DPI, which is the usual size for displaying an image on the internet. However, to ensure high quality you should print your artwork at a minimum of 300 DPI.

So what size resolution should you choose?

As a rule, it's best to work on a document at 300 DPI, if you want to avoid problems when printing your work at a later date. You can always scale artwork down for the internet, but scaling digital artwork up may result in a loss of quality and increased pixelation.

Workspaces

Although every new version of Photoshop looks slightly different, the overall layout of the workspace remains the same. Here's how to find your way around it.

What's on screen?

The Menu Bar is located at the top of the screen, giving access to the majority of Photoshop's functions.

The *Options Bar* is located immediately beneath the *Menu Bar*. Here you will find options you can modify, depending on the tool you have selected at the time.

The Toolbox is on the far left of the workspace and contains a number of icons for tools. The tools are collected into groups that perform a similar function – for example, selection, painting and editing, path and shape and so on.

Most of the screen space is allocated to the document window (the area where you paint).

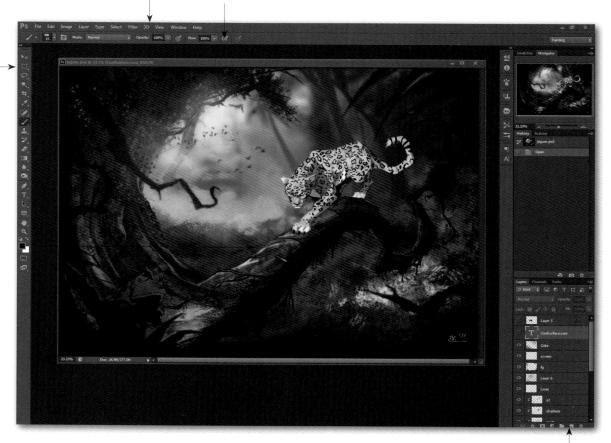

On the far right is the *Panel Dock*, which gives you an editable selection of panels. These include the 'History' palette and access to layers, channels, colours and swatches.

In Photoshop CS5 and CS6, you have the option of automatically assigning a workspace. For example, you can choose a workspace for painting or for 3D and Photoshop will offer you the relevant tools for your task.

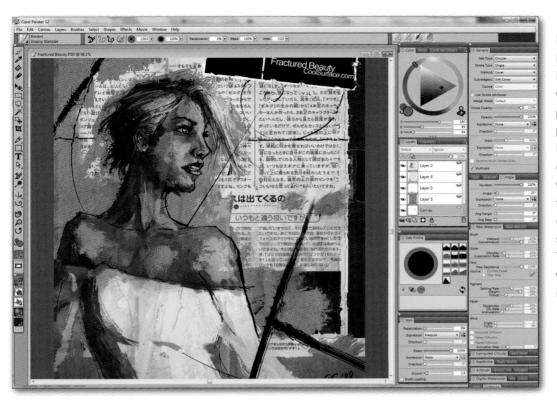

For Photoshop users, Corel Painter 12 features an instantly familiar workspace with the main toolbar and palettes located in the same positions as for Photoshop. Painter 12 features an option to apply alternative workspaces created by artists for specific methods of drawing, such as a concept sketching and illustration. There is also a creativity workspace for generating ideas quickly.

Autodesk Sketchbook
Pro features a more
open workspace
than Photoshop
and Painter 12.
A dock at the
bottom left gives
access to tools.
There are fewer
tools available
in this program
than in others, but
Sketchbook allows
you to edit your
work to perfection.

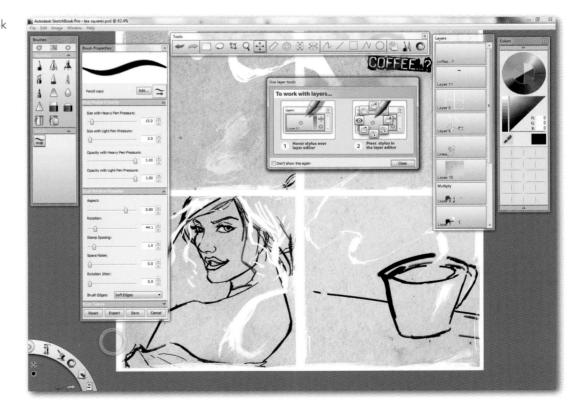

Pixels and Vectors

There are two ways of working digitally – with pixels or with vectors.

Pixel-based artwork

Pixel-based (or pixel-element-based) artwork (also referred to as raster or bitmap graphics) is made up of a large grid of tiny squares. Each square is assigned a colour. The coloured squares are used to build up an image which looks like flat colour when viewed from a distance.

Pixel images are great for painting and photography as they can be used with ease to achieve a wide range of tonal variation. Although a pixel image can be scaled down successfully, the quality is impaired if you attempt to increase its size. Pixel images are favoured by programs such as Adobe Photoshop, Corel Painter and Autodesk Sketchbook Pro. These programs typically aim to replicate a traditional style of working. If used with a pen stylus, the result is very similar to drawing or painting.

Vector-based artwork

Vector-based artwork differs from pixel-based artwork to the extent that it relies on mathematical algorithms to determine the shape and size of all lines drawn. Vector graphics are ideally suited to logo design and typography, as they can be scaled infinitely and remain crisp no matter how large you make them or how closely you zoom in. Vector-based programs are best used in conjunction with the *Pen Tool*. Manipulation of the *Pen Tool* can take a bit of getting used to, but it offers great control and precision.

Vectors are used in programs such as Adobe Illustrator, Flash and certain tablet-based drawing apps. However, vector-based artwork programs are not suitable for images with large areas of tonal detail.

Basic Non-Creative Tools

These Photoshop tools are good for assisting with creative tasks, but aren't used for creative purposes on their own.

The Move Tool

The Move Tool is used to manipulate elements of the image. Holding down the Shift key before using the Move Tool constrains movement to horizontal or vertical straight lines; holding down the Alt key before using the Move Tool duplicates the layer.

With the *Move Tool* selected, you can use the arrow keys to nudge things one pixel at a time. Right clicking with the *Move Tool* gives you a list of layers with a pixel on them beneath the current location.

 \triangle Using the Rectangular Marquee Tool

The Marquee Tools

The Marquee Tools allow you to make a selection from a predefined shape, for example, a rectangle, an ellipse, a single row or a single column. They can be set to create a new selection with each mouse click. Alternatively you can set the Marquee Tools to add or subtract from selections and to intersect with them. All selections can have their margins feathered (blurred) to give a soft-edged effect.

The Lasso Tools

The Lasso Tool allows you to trace out selections. There are three types of lasso. The freehand Lasso Tool is used to manually trace the areas for selection.

 ∇ The *Polygonal Lasso Tool* makes a selection of multiple points in straight lines.

□ The Magnetic Lasso Tool guesses the pixels you want to select and snaps to the edges of an object by measuring the contrast of the neighbouring pixels. If the colours you are working with are very similar, you can alter the levels of tolerance in the Options Bar.

The Magic Wand Tool

The Magic Wand Tool works a little differently from the other selection tools. It makes selections based on the colour you click on. With a low tolerance setting, the Magic Wand Tool will only select colours close to the first colour you click on; to select a broader range of similar colours, simply use a higher tolerance setting.

The Quick Selection Tool

The *Quick Selection Tool* (added in Photoshop CS3) is a more advanced version of the *Magic Wand Tool*. It lets you paint your selection with a brush; you can change the size of the brush as and when you need to.

The Crop Tool

The Crop Tool has a number of useful functions beyond simply cropping unwanted areas from an image. You can rotate an image as you crop it by releasing the mouse button and dragging one of the corners of the marquee.

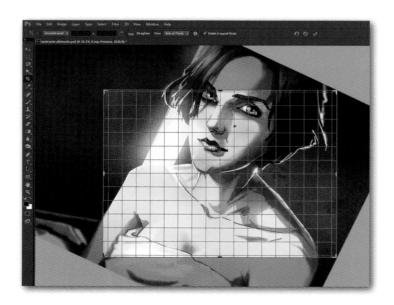

With the *Perspective Crop Tool* you can correct any distorted perspectives in an image by dragging the handles manually to match the areas you want straightened.

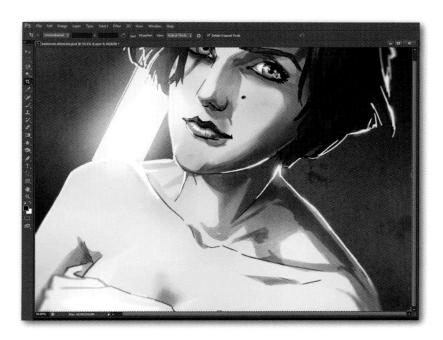

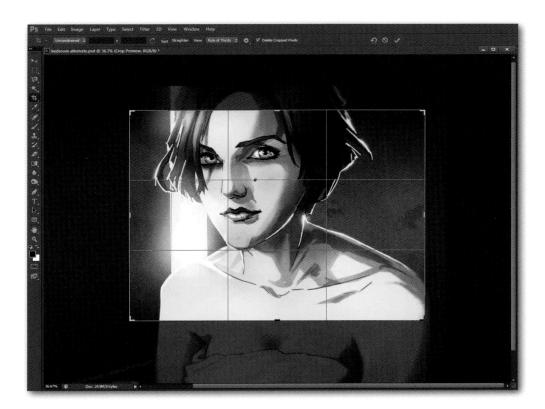

You can also set the *Crop Tool* to hide the cropped area instead of permanently deleting the pixels.

You can automatically crop different images to one specific size by selecting your active image and clicking on the 'Front Image' button in the *Options Bar*. Now, when you use the *Crop Tool* on another image, it will automatically match the size of your original image.

The *Crop Tool* doesn't just reduce the size of images. If you drag the handles beyond the boundary of your canvas, you will increase the size of your document.

Colour Selection

There are several ways to select colour.

Clicking on one of the two colour squares in the bottom of the *Toolbox* will open the 'Color Picker' dialog box. Here you can choose your colour either with the *Eyedropper Tool*, by clicking in the 'Foreground Color' box, or entering the colour value manually by choosing the RGB or CMYK.

You can select the *Eyedropper Tool* from the *Toolbox* and click to sample a colour from any open document.

Alternatively, when you use the *Pencil*, *Brush* or *Paint Bucket Tool*, you can press the Alt key to access the *Eyedropper Tool* to select a colour quickly. You can also select colours and swatches from the 'Colour Swatches' palettes.

If you are having difficulty making a choice of colours, you can always sample a colour swatch from an image you like. Open the image and click *Image>Mode>Indexed Color*. When the 'Indexed Color' dialog box appears, use the following settings: *Palette: Local (Perceptual), Colors: 256, Forced: None.* Then click OK.

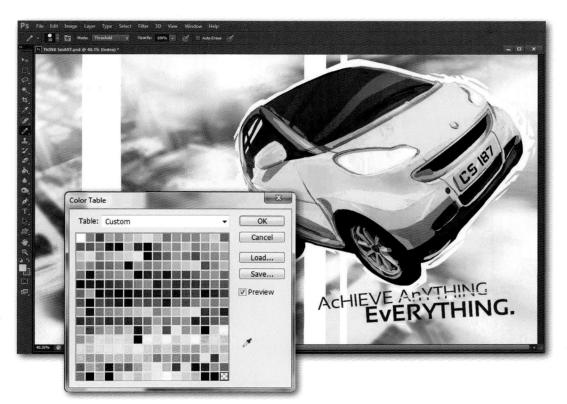

Now click Image>Mode> Color Table. Click to save and name your table – it will be saved as an ACT file. Save it into your Photoshop/ Presets/Color Swatches folder so that you can access it at any time.

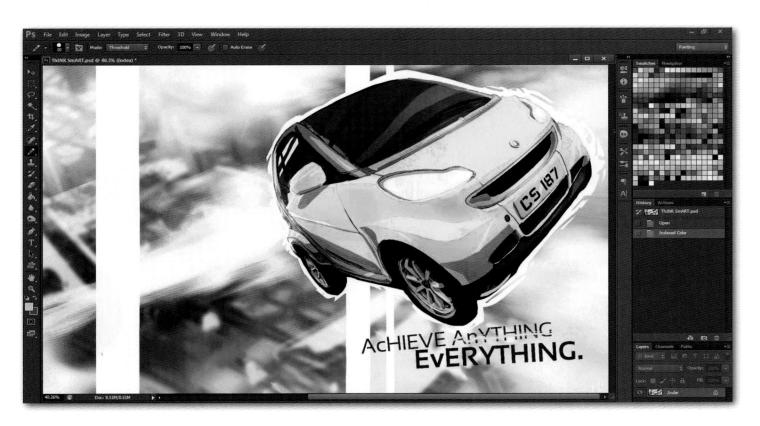

Saving and Exporting in Different Formats

There are numerous file types with which you can save your work. Here is a quick rundown of some of them.

PSDs

PSD is Photoshop's native file format and it is supported by most digital art programs, including Painter and Sketchbook Pro. It supports multiple layers and effects, which will make files larger. PSDs are a lossless format, which means that you can save repeatedly without harming the image.

JPEGs

JPEGs are the best way of presenting images online or sending via email. The compression is fantastic – file sizes reduce dramatically without too much loss of quality. However, JPEGs do not support layers and the more times you save the same file, the greater the amount of image degradation. It's best to save as a JPEG only when your artwork is finished and no longer requires editing. With JPEGs, you can choose the level of compression you apply to images so that you can control exactly how small the files become. This will affect the image quality, but only by a negligible amount. Photoshop has a 'Save for Web' function that results in a very internet-friendly image size with an almost indiscernible loss of quality.

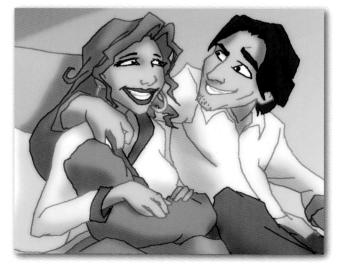

GIFs, PNGs and TIFFs

A GIF file is limited to 256 colours; it is effective for simple images, but should not be used for anything complex.
GIF files can support basic animations suitable for the internet.

A PNG file supports up to 16,000,000 colours and is a lossless format. With PNGs, it is possible to have a transparent background (something unachievable with JPEGs). However, PNGs are often larger than JPEGs so tend to be used less frequently.

A TIFF file is similar to a PSD in that it supports multiple layers and interfaces well with most digital art programs. However, although TIFFs can save adjustment layer preferences for future tweaking, the file sizes are much larger than PSDs.

Which Digital Art Program is Right For You?

Each of the programs covered here has its own special features for producing particular digital art effects.

Sketchbook Pro

If you are looking for a program with which you can get started straightaway, then Autodesk Sketchbook Pro is a great choice. It has fewer bells and whistles than other programs so is easy to grasp quite quickly. Lots of artists start off in Sketchbook Pro, sketching and producing finished line work; they then move their files over to Photoshop to colour and add effects.

Corel Painter

'Designed by artists, for artists', Corel Painter is a highly sophisticated program that produces naturalistic digital artwork with traditional paint effects from watercolours to pastels, oil paints, pencils and inks.

Painter offers various workspaces tailored to whatever style of painting you desire. As its layout is a lot like Photoshop, it is easy to transfer to Corel Painter if you are familiar with the former program. While Painter doesn't include many of the more advanced Photoshop tricks and layer styles, it is still the best program for traditional paint effects.

Adobe Photoshop

Adobe Photoshop offers the greatest number of options for creating digital art, encompassing all areas from traditional painting to photo retouching. It involves a fairly steep learning curve to begin with, as the interface is far from intuitive, but once you are familiar with this program you will find it extremely versatile.

Adobe Illustrator

For vector drawings, logo design, typography and pattern design, you can't beat Adobe Illustrator. However, this program doesn't produce hugely naturalistic work and is not the best at handling textures. It is often used in conjunction with Photoshop to achieve the best results.

Which Digital Art Program is Right For You? // 21

Chapter Two:

Creative Tools

This chapter describes the various creative tools available in digital art programs. It suggests tips and tricks for using them effectively and examines ways in which you can use Photoshop's functions to improve your artwork.

The Pencil Tool and Aliased Pixels

The *Pencil Tool* is probably one of the most misunderstood tools in Photoshop. At first glance it appears to be a slightly inferior version of the *Brush Tool*. It uses blocky, aliased pixels rather than the smooth, anti-aliased pixels of the brush, but this isn't necessarily a disadvantage.

Crisp lines

Aliased pixels make nice crisp lines which, at high resolution, look remarkably like scanned pencil lines. Aliased pixels also allow you to fill in areas of colour precisely and rapidly.

Colour fill

Once you have ensured that there are no gaps between your lines drawn with the *Pencil Tool*, switch to the *Paint Bucket Tool* (making sure you un-check the 'Anti-alias' option in the toolbar). Now fill away. If you want to keep your lines on a separate layer, use the *Magic Wand Tool* to select the area to be filled on the 'Lines' layer, then move on to your colouring layer and fill in.

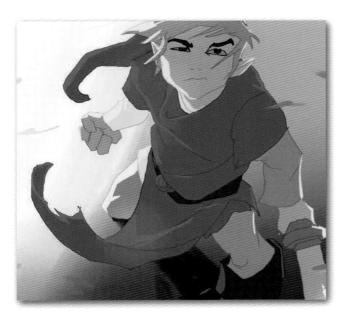

Editing colours

Not only is this a speedy method of flat colouring, aliased pixels also allow you to edit colours with minimal hassle.

TECHNICAL TIP

Don't free transform your lines until you've filled everything with colour. Once you have transformed the lines, they will be anti-aliased and won't fill correctly to the edges.

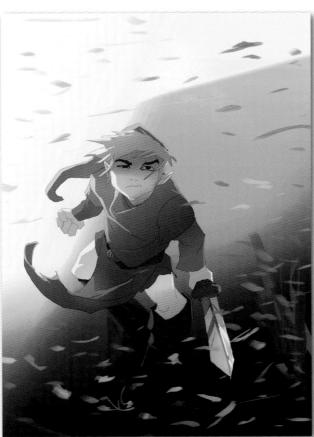

Using aliased pixels allows you to colour right to the border so that you can re-colour an entire area with one paint-bucket fill.

You can change the mood of your image in minutes. With just the *Paint Bucket Tool* and an orange layer set to *Soft Light*, the illustration has altered significantly.

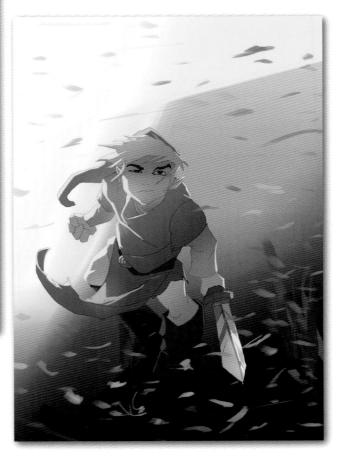

The Brush Tool

The *Brush Tool* in Photoshop is extremely versatile and will help you achieve an almost limitless number of effects.

Brush libraries

Photoshop has a range of excellent brush libraries divided into various brush effects. You can choose to use just one set or append multiple sets together. The 'Brushes' palette gives you the option to customize brush effects further.

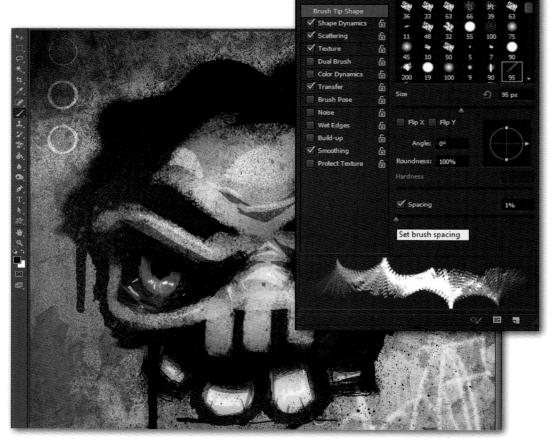

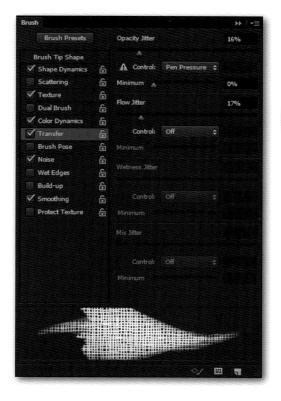

Scattering multiplies the number of times that Photoshop will draw the brush-tip shape in a brushstroke. It disperses the shapes along the line you've drawn. You can alter the number and direction of the scatterings.

If you set the Size Jitter and Opacity and Flow Jitters to 'Pen Pressure', your brush will act intuitively and feel like a real paintbrush. The harder you press down on your stylus, the bigger and bolder your brushstrokes will be. If your stylus allows it, set the Angle Jitter to 'Pen Tilt' to make your painting even more authentic.

Increasing or decreasing the spacing of a brush can dramatically change its effect. To see how this works, try looking at the 'Brush Preview' window when you click and drag the Spacing slider from left to right.

Applying texture to your brushes breaks up the brushstroke and adds a natural grain to your painting.

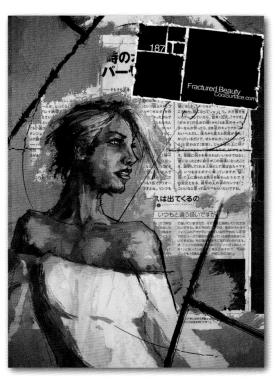

TECHNICAL TIP
Using the square bracket
keys ']' and '[' increases and
decreases your brush size.
This is much more efficient
than changing your preset
or dragging the Size slider
around in the toolbar.

Enabling the *Dual Brush* will combine two brushes of your choice; this can result in unpredictable outcomes.

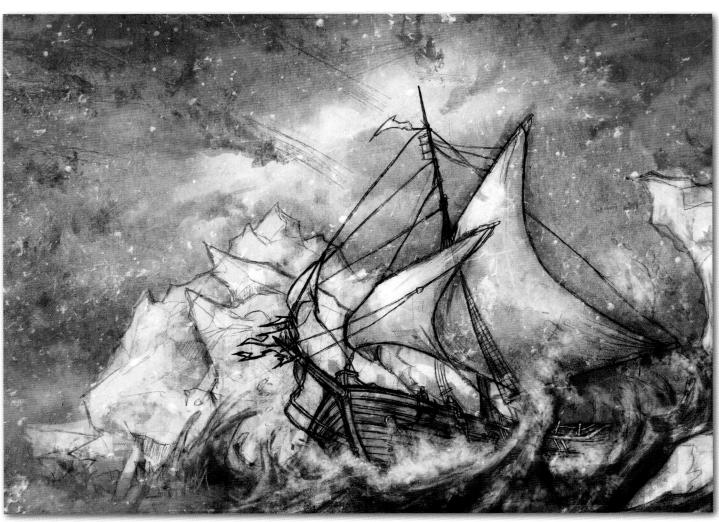

Bristle Brushes and the Mixer Brush

Introduced in Photoshop CS5, bristle brushes have virtual bristles that react to tilt and pressure in a much more advanced way than earlier Photoshop brushes. When you press down with a bristle brush, the bristles splay out on the virtual canvas, just like a real paintbrush, resulting in expressive brushstrokes. Bristle brushes offers much more variety than Photoshop's older static brushes.

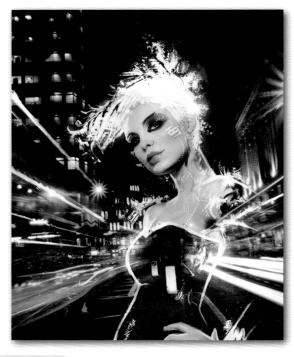

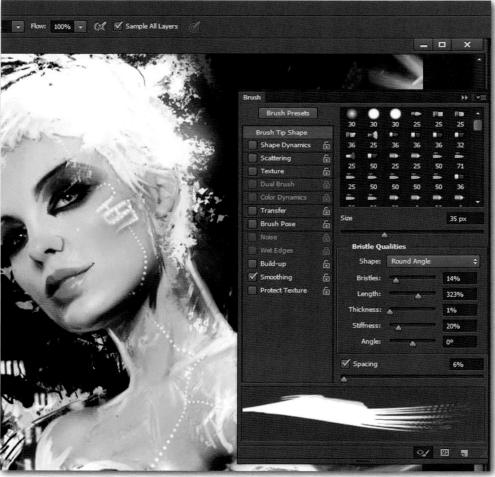

Bristle qualities

The *Bristles* slider affects the number of bristles in the brush – a high percentage gives a smooth brushstroke, a lower percentage lets you see the individual bristle marks in the artwork.

The Stiffness slider alters the rigidity of the brush – a high percentage makes brushstrokes predictable, a lower percentage allows the bristles to move freely, giving expressive strokes.

The preview box at the bottom of the facing page displays the exact angle at which your brush is tilting, so you can see the position of your brush and the mark it will make on the canvas.

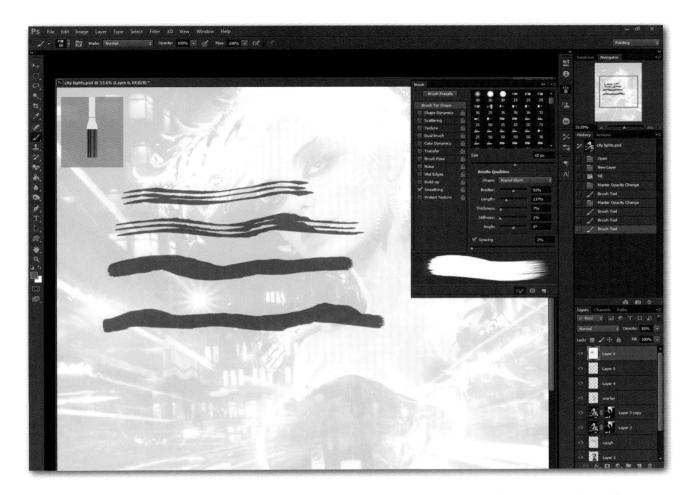

The first stroke in the image above is 'low bristles' and 'high stiffness'; the second stroke is 'low bristles' and 'low stiffness', the third stroke is 'high bristles' and 'high stiffness'; and the fourth stroke is 'high bristles' and 'low stiffness'.

The Mixer Brush

The *Mixer Brush* uses the bristle brushes to pick up the digital paint you've already laid down on the canvas and to mix the colours you have on each bristle.

With the 'Mix Mode' drop-down menu, you can quickly change the wetness, paint load and mixing levels without having to tweak each setting. This makes painting feel quick and natural. The best feature about the *Mixer Brush* is its non-destructive painting. You can paint on a separate layer over your artwork because the *Mixer Brush* can sample from all the layers beneath it. This protects the artwork from damage.

The Pen Tool

Photoshop's *Pen Tool* does not work as you might expect. Although its name suggests freehand drawing, the *Pen Tool* is, in fact, used to plot a series of anchor points to create paths with 'Bézier' curves.

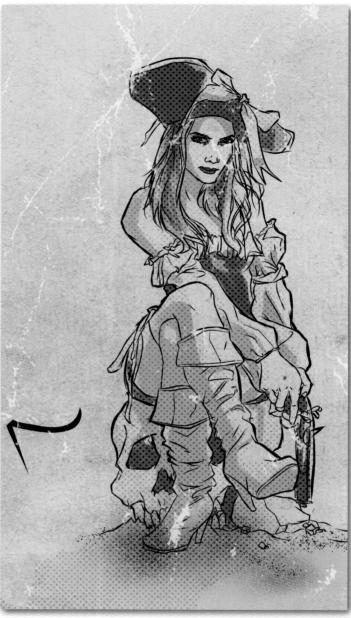

To start a path, click on the canvas with the *Pen Tool*. A second click will create a line between the two anchor points. Click and hold on the second anchor point, then start dragging your cursor to make a Bézier curve.

Using handles

You can make a perfect curve up to a 90° angle. Use the handles that appear after clicking and dragging to control the arc of the curve. Click on an existing anchor point to remove it. To close your path, click on the anchor point with which you began the sequence.

If you have two handles, the curve can be difficult to manipulate. To remove one of the handles, hover the cursor over the anchor point and mouse-click while holding down the Alt key.

Creating smooth curves

For a smooth effect, place additional anchor points on the path between two curves. Once your path is complete, you can stroke it to create line work or turn it into a selection by right-clicking over the path itself or in the 'Paths' palette. The path or selection can then be filled. The path can be accessed at any time in the 'Paths' palette, so you only have to draw it once.

The Eraser Tool

The *Eraser Tool* can be used both for correction and effect.

Eraser modes

The Eraser Tool has three modes: 'Brush', which gives soft, anti-aliased edges; 'Pencil', which makes hard, aliased edges; and 'Block', a square brush. You can make the effect subtler by altering the opacity of the eraser in 'Pencil' and 'Brush' modes. You can also alter the flow in 'Brush' mode. The options to alter opacity and flow are not available in 'Block' mode. If you want to create subtle, faded edges, use an airbrush eraser set to 50% opacity with 'Pen Pressure' enabled.

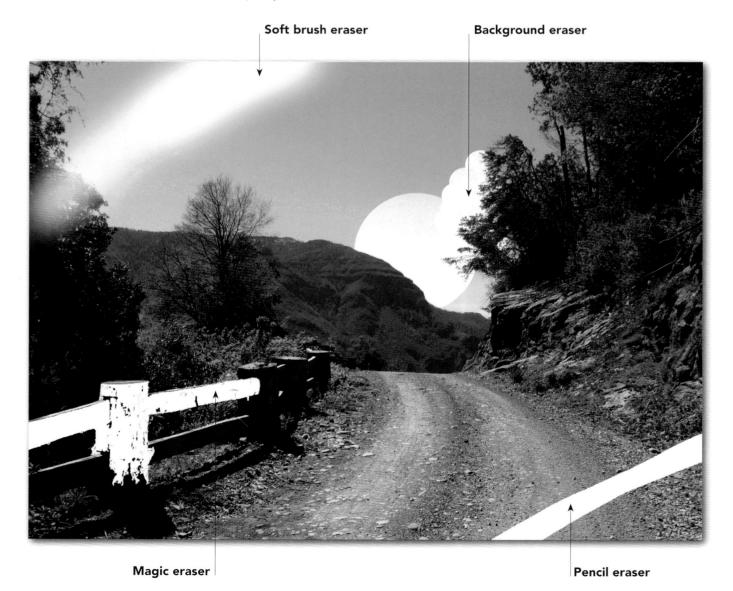

The Magic Eraser Tool

The Magic Eraser Tool removes all colours within a defined tolerance setting. With one click, the surrounding colour is erased – there is no need to drag the cursor. The Magic Eraser Tool is great for quickly rubbing out large expanses of colour.

The Background Eraser Tool

The Background Eraser Tool removes the background behind complicated foreground elements such as trees. It samples the colour at the midpoint of the cursor at the moment of clicking. Then, as you drag the brush across the image, it erases every pixel of the sampled colour while leaving other colours untouched.

Moving the cursor over a new colour will resample and erase it as well, so be careful how you use this tool. To be on the safe side, set the *Background Eraser Tool* to sample the colour once in the *Options Bar*.

If you are erasing similar colours, you can lower the tolerance of the *Background Eraser Tool* so that it only erases specific shades.

The Background Eraser Tool is particularly useful if you want to replace a bland-looking sky with a more dramatic one.

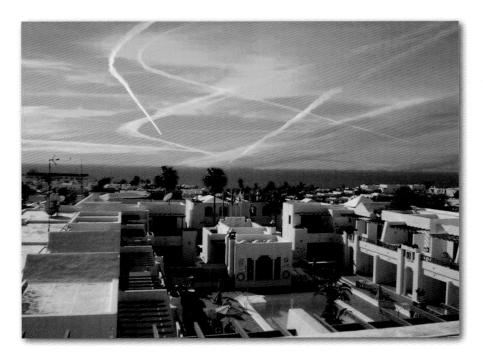

The Custom Shape Tool

At first glance, the *Custom Shape Tool* looks as though its only function is to add basic clip art to Photoshop, but there is more to it than meets the eye.

Making a stamp

The *Custom Shape Tool* works by selecting a predefined symbol and dragging it to make a stamp of it. The stamp can be distorted depending on how you drag the bounding box. Using the *Custom Shape Tool* in this way means that it becomes more like a custom brush tool – it's good for adding random or chaotic detail to images.

When you use the *Custom Shape Tool*, you can make an individual shape layer. You can then generate a path from the shape you've just created. Alternatively, you can generate pixels based on the shape you have made.

Each custom shape can be tailored to your needs. It can be filled with a pattern gradient, flat colour or left blank with just a stroked outline.

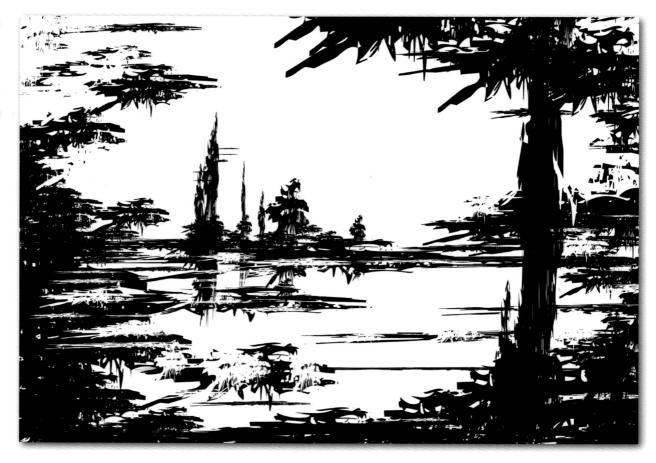

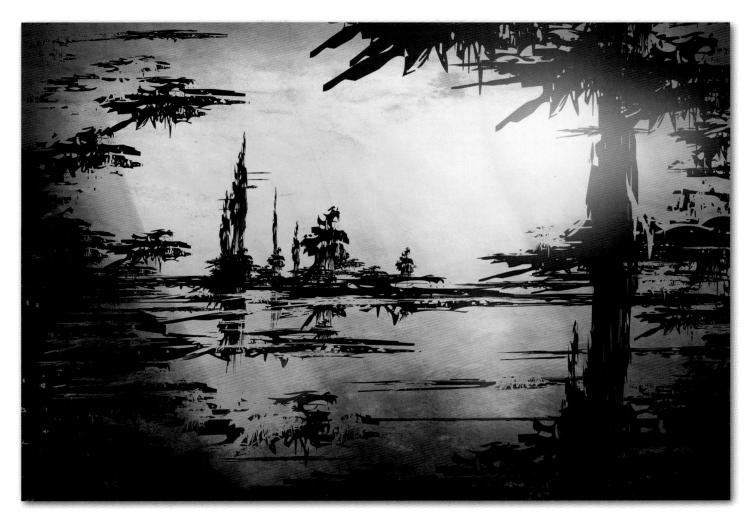

This image has been made using the custom shape shown on page 32. By stretching the shape vertically and horizontally, a strong silhouette is created very quickly. First black and then white is used to cut into the shapes to create variety. The mood of the image is further enhanced by the addition of some texture overlays.

Lots of different shapes

When you first access the custom shapes, it may appear that there are only a limited number. However, by clicking on the arrow for the shapes' fly-out menu (located in the Options Bar) you can display all the custom shapes available. Suddenly you'll find you have a lot more to play with! As always, you can edit and create new custom shapes, and many more are available on the internet as free downloads (see page 128).

The Type Tool

Access the *Type Tool* by pressing T or clicking on the 'T' icon in the *Toolbox*. The *Type Tool* creates vectored letters horizontally or vertically or as typeshaped masks.

Creating type

You can create type in two ways: either by clicking the mouse at the point where you want to begin and then typing using the keyboard, or by clicking and dragging to select an area where the type will appear in a paragraph. For both options, once you have finished writing your text you need to commit the type to a separate layer by clicking the tick icon.

Transforming

If you want to transform your text, you can use the normal Free Transformation Tools. The best way to do this is to click on your paragraph text with the Type Tool and drag to resize the handles. The text will automatically reformat to fit the bounding box. To skew the text in your direction of choice, hold down the Cmd and Ctrl keys while you are dragging the handles.

Managing fonts

Fonts are fully editable – you can change their size and colour and you can kern (alter the distance between characters). You can 'warp' text to a predefined shape or alter the settings manually. You can also type on a path, after first drawing the path with the *Pen Tool*, or by creating a vector shape and then clicking the *Type Tool* on the path.

You can convert type to a fully editable shape by clicking Layer>Type>Convert to Shape. This feature is great for designing logos. Once the type has been converted, you can use the Direct Selection Tool to manipulate the anchor points of each letter in the same way as you would with the Pen Tool.

Pressing Ctrl + T creates a bounding box around whatever elements you have on your layer. The box has four corner handles and a reference point in the centre. Grab a handle and drag it to alter the shape of the element.

The Free Transform Mode

Often referred to as the *Free Transform Tool*, this mode allows you to change the size and shape of any element on a layer.

Resizing

If you hold down the Shift key while dragging a handle, you constrain the proportions and maintain the aspect ratio of your element. This allows you to resize it without distorting it. If you hold down the Alt key while dragging the handle, you move the sides of the element an equal distance from the centre reference point.

Rotating

If you hover your cursor outside the corner of the bounding box, you can rotate the box's contents. Hover inside the box to move the content.

Rotating the box causes the contents to move around the centre reference point. If you want the rotation to be centred on a different point in the box, click and drag the reference points – to a corner, for example. This will form a new axis around which the contents rotate.

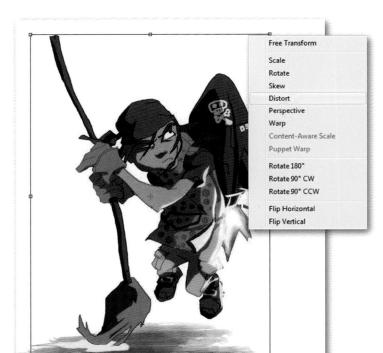

Modifying

Right-clicking anywhere within the bounding box allows you to make modifications such as *Skew, Distort, Perspective* and *Warp.* It also gives you access to simple controls such as *Flip Horizontal* or *Flip Vertical*.

Clicking on Warp while using the Free Transform Tool will superimpose a grid on the bounding box. You can then warp specific parts of the image by dragging the grid's anchor points.

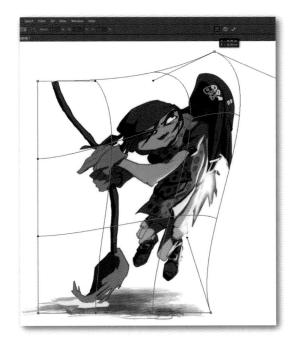

Blurs

With blurs, you can precisely control the focus of an image. In older versions of Photoshop, one of the most useful blurs is the *Gaussian Blur*, which softens all pixels within a selected area.

➤ The Radial Blur can be set to spin or zoom to simulate a dramatic camera effect. All Photoshop's traditional blurs offer a 'Preview' window with editable options you can choose from.

The CS6 Blur Gallery

Photoshop CS6 allows you to apply blurs directly to an image with even greater precision; you can also manipulate the blurs in real time!

Description The Iris Blur brings up an ellipse that you can manipulate to dictate the areas you want to blur. This works well in drawing your attention to items in the centre of

an image.

the results are very precise.

✓ With Field Blur, an image is blurred when you apply pins

to it. Pins allow you to control the level of blur surrounding

them. You can apply as many pins as you like to an image, so

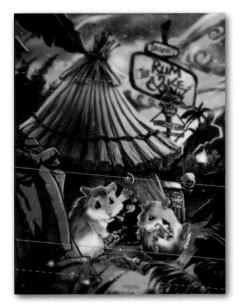

Description The 'Blur Effects' panel in the lower part of the Blur Gallery has content controls to simulate 'bokeh' effects. (Bokeh is the way in which a camera blurs and renders out-of-focus points of light.) The Light Bokeh slider controls the intensity of the effect, the Bokeh Color slider allows you to boost the saturation and the Light Range slider enables you to select the darkest and brightest pixels to be affected.

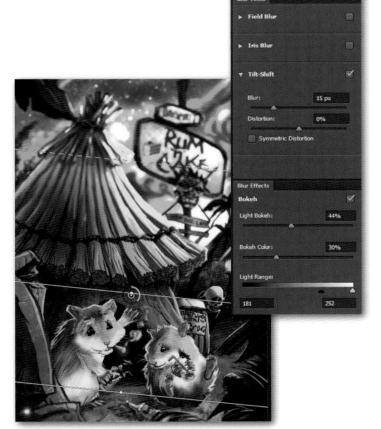

Filters

There is a tendency for first-time users to deploy filters indiscriminately to create 'instant art'. However, a little restraint is the key to using filters.

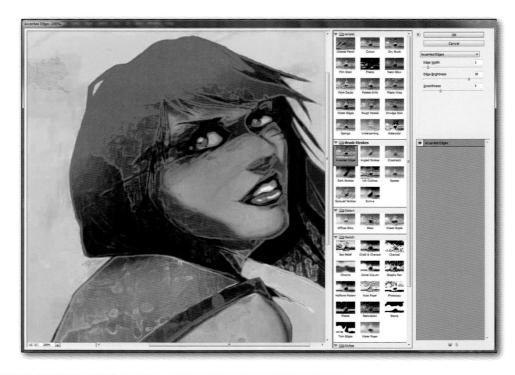

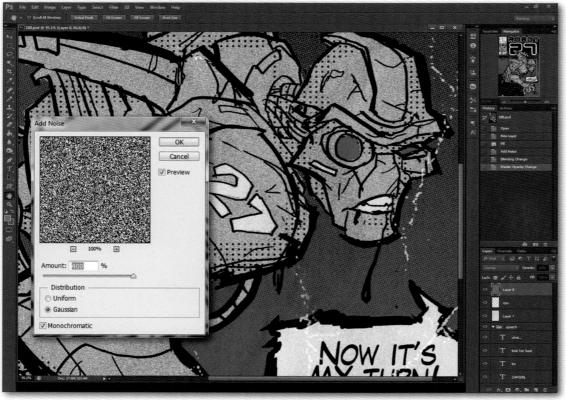

The Filter Gallery

Filters allow you to change the appearance of an image, layer or selection in a few simple clicks. To access the Filter Gallery, you need to click through the 'Filter' menu.

The Filter Gallery is divided into a 'Preview' window on the left, a filter selection column in the middle and a choice of filter options on the right. If you already know which filter you want, you can bypass the Filter Gallery and access your chosen filter directly from the 'Filter' menu.

Some of the most useful filters are blur filters and noise filters which add noise and grain to your images. The 'Noise' filter can be used to add a layer of detail and prevent banding effects when using gradients. The 'Reduce Noise' filter is good for repairing old, damaged photographs.

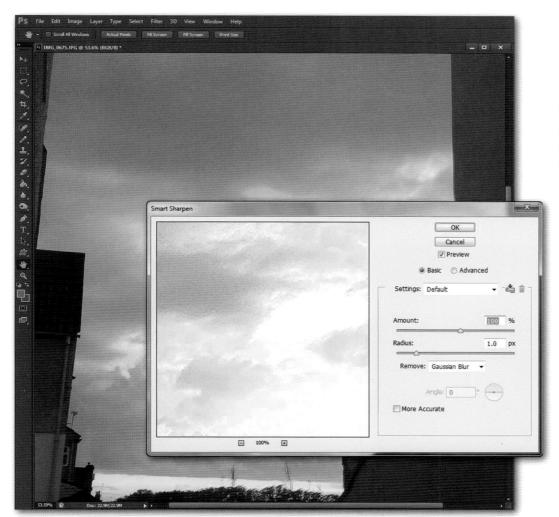

'Sharpen' filters help to define blurred images by increasing the contrast between pixels.

If a filter isn't working, it's worth checking that you are in RGB mode, as some filters only work in RGB. Also, certain filters are processed entirely in RAM. If you're having problems, try turning off other programs to free up some RAM and then reopen Photoshop.

There are numerous high-quality filters that you can download for free from the internet.

Layer Masks

Layer masks allow you to hide pixels and bring them back at will. Instead of erasing something permanently, you can apply a layer mask to obscure the area. This gives you more flexibility when working in Photoshop.

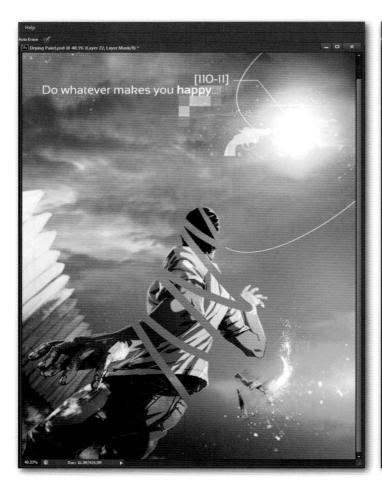

You can apply a layer mask by clicking on the circle in the square icon at the bottom of the 'Layers' palette. Then use a brush to paint with black to hide pixels (use white to reveal them again). Alternatively you can use the selection tool of your choice (for example, the *Lasso Tool*) to designate an area in which to apply the layer mask. Using a shade of grey will reduce the opacity of a pixel, making it translucent instead of masking it completely.

Clipping mask layers

The 'Clipping Mask' layer acts in the same way as a standard layer mask, but uses the layer beneath as a guide for where pixels should be added. New pixels will only appear over existing pixels beneath; if the area beneath is clear, no new pixels will appear. Clipping mask layers are useful for actions such as applying shading to characters, because they ensure you avoid getting shading on the background as well.

Do whatever makes you har

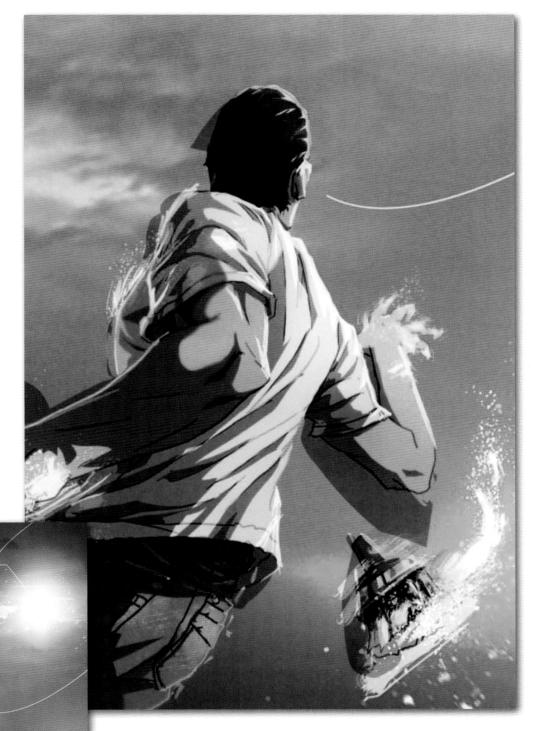

 \triangle This is what the shading looks like when the clipping masks are released, revealing all the brushwork.

Blending Modes

Blending modes affect how layers interact with one another in an image. Blending modes have individual features, but are grouped into similar effects.

The default setting for any new layer is 'Normal'. Click in the 'Layers' palette to change the blending mode of a layer; this will alter the appearance of your image, depending on the layers beneath your active layer.

Darkening effects

This group includes *Darken*, *Multiply*, *Colour Burn* and *Linear Burn*. All these blending modes will make your image significantly darker. *Multiply* is the most reliable mode to choose; it darkens the lower layer in relation to the upper one. White becomes transparent, which is useful for actions such as painting underneath a layer of scanned artwork (the lines remain, but the paper is invisible).

Lightening effects

This group includes Lighten, Screen, Colour Dodge and Linear Dodge. All these modes will make your image lighter. Screen, the light equivalent of Multiply, is the most popular choice; it lightens the lower layer in relation to the upper one.

Contrast boosting effects

This group includes Overlay, Soft Light, Hard Light, Vivid Light, Linear Light and Pin Light. Each of these modes employs various methods of increasing contrast. The outstanding effects here are Overlay and Soft Light. Overlay multiplies light colours and screens dark colours; Soft Light multiplies dark tones and screens light tones. You may find that lowering the opacity when using these modes will help to get the exact look you want.

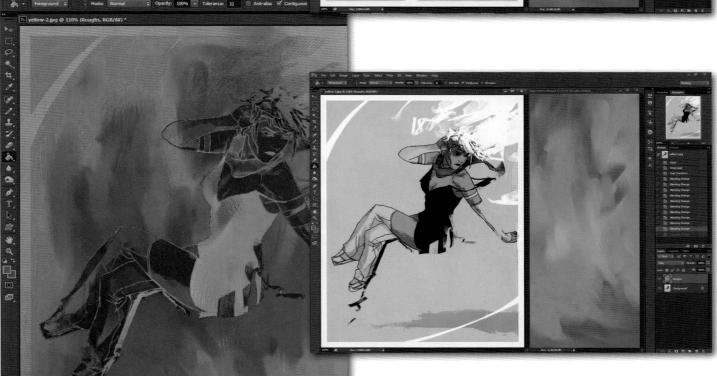

Inversion effects

The modes *Difference* and *Exclusion* react to the differences between the upper and lower layers.

Component effects

The modes Hue, Saturation, Color and Luminosity all affect an element of their group, while leaving other elements unaffected. For example, Saturation lowers the saturation, but does not alter the hue or luminosity.

Use the arrow keys to cycle quickly through the various blending modes to see which work best for your image.

Chapter Three:

Creative Concepts

Whether you are working digitally or traditionally, the concepts covered in this chapter offer tips and insights that result in stronger and more effective final artwork.

Composition

Composition, or how you arrange the visual elements in a picture, is vital to its success. There is little point in being able to draw technically if your composition is weak.

It's best to visualize your composition first in thumbnail form, so that you get the overall balance correct before starting to work on the details. If an image is effective at the size of a postage stamp, it will work at the size of a billboard!

Purely symmetrical and balanced compositions (with the main subject positioned centrally in an image) tend to be predictable and dull. Images that excite and stimulate us use asymmetry; this is because elements that are off-balance create tension and movement.

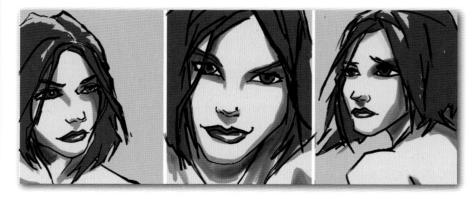

Camera angles

It's important to consider the camera angle you use in an image. A close-up shot (see above) will lend an air of intimacy and enable the viewer to gauge a character's feelings.

A low-angle shot (see right) will increase the viewer's identification with the scene. It will also make the character in an image appear either strong and heroic or domineering and menacing.

A high-angle shot (or bird's-eye view) will make the viewer feel more like a spectator or eavesdropper than someone who is directly involved with the scene. A long shot like this is great for establishing environment and atmosphere, but it doesn't encourage emotional involvement.

Pointers

Strong lines and shapes lead the viewer's eye around the image. Interest is maintained through various 'pointers' which guide the eye towards areas of interest. The use of darker, out-of-focus framing elements also draws attention to other areas of interest.

Pointers to main focal point

Pointers to other areas of interest

Leading the Eye

In any picture, the viewer's eye will first be drawn to the area of greatest contrast or to something irregular in the image. If all other elements are the same, then the eye will be drawn to the one element that's different.

Contrast

Shading in black or white provides the greatest contrast, so these tones should be used for the most important parts of a grayscale image. Alternatively, you could make your focus a single element of colour in an otherwise monochrome image, or the strongest value of colour in a full-colour image.

Focus

You can use additional elements in the image to help create a focal point. A spotlight or elements radiating from a character will all draw attention to it.

However, an excess of visual clutter is unappealing and means the viewer's eye can't settle anywhere in an image. Every image needs some breathing space. Typically this is provided by an expanse of sky, but it can also take the form of a large, still body of water or a blank surface, such as a huge rock on a mountainside, or a large area of open ground viewed from a high-angle shot.

Perspective

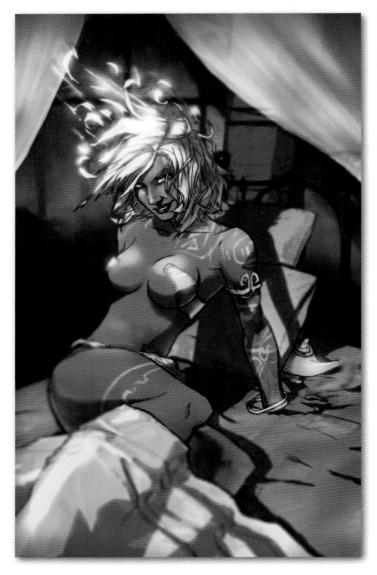

Above, overlap is used subtly to display the 3D space of the image. The character's arm overlaps the pillow, which in turn partly obscures the lamp; and these elements overlap the bed rail. The veil-like curtain also covers part of the bed rail. This overlapping technique gives the viewer a good idea of how the various elements relate to one another.

Any basic tutorial will teach you that things appear to get smaller the further away they are and bigger the closer they are – but there's more to achieving successful perspective than this.

Overlap

The inclusion of overlapping elements gives the impression of a 3D space with multiple planes. The absence of overlapping elements means that this depth of field may be lost.

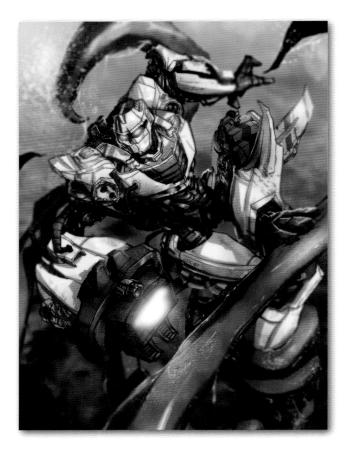

This image also shows the use of overlap. The robot and the tentacles overlap one another repeatedly, which helps to show how entangled the characters are in battle.

Repetition and angles

Elements such as trees, lamp posts or fence posts can be drawn repeatedly as increasingly distant objects to help convey perspective.

Although this is a useful technique, be careful to avoid making the objects too similar or spacing them too evenly. This will make your image dull and monotonous. Use uneven spacing and overlapping elements to create visual interest.

In the above image the trees and fence posts are drawn at various angles to add interest and make the forest look deeper.

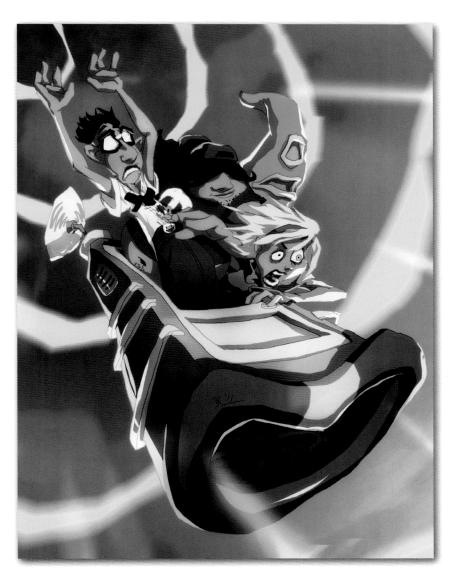

In this image, the yellow 'time portal' effects help to emphasize the foreshortening of the image.

Reflected and Ambient Light

Reflected light is the light that bounces off the surface of a subject onto surfaces surrounding the subject, and vice versa. Ambient light is a general illumination that comes from all directions and has no visible source.

Reflected light

Reflected light is always located on the subject's shadow side. When light hits a surface, it bounces off it and changes colour. If it hits another surface of the same colour, the saturation of the colour will increase.

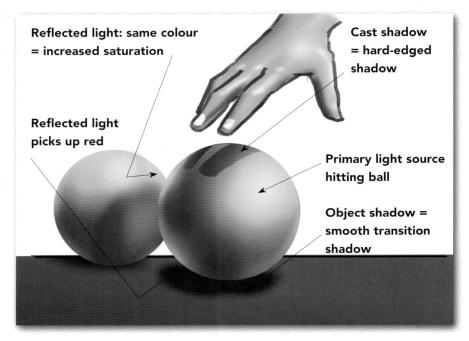

In this image, the primary light source is in front of the subject (woman and gorilla) and the secondary light source is behind the subject. You can see the light bouncing off the gorilla's arms. Light also bounces off the tree trunk and makes it appear green; the surrounding foliage, which is in shadow, appears blue.

Radiosity

Reflected light (known as 'radiosity' in 3D computer graphics rendering) helps to unify an image by making everything look like part of a single scene, rather than a collection of disparate elements. Reflected light helps to add depth even to stylized 2D drawings.

Reflected light hits the underside of the gorilla's face, which would otherwise be in total shadow.

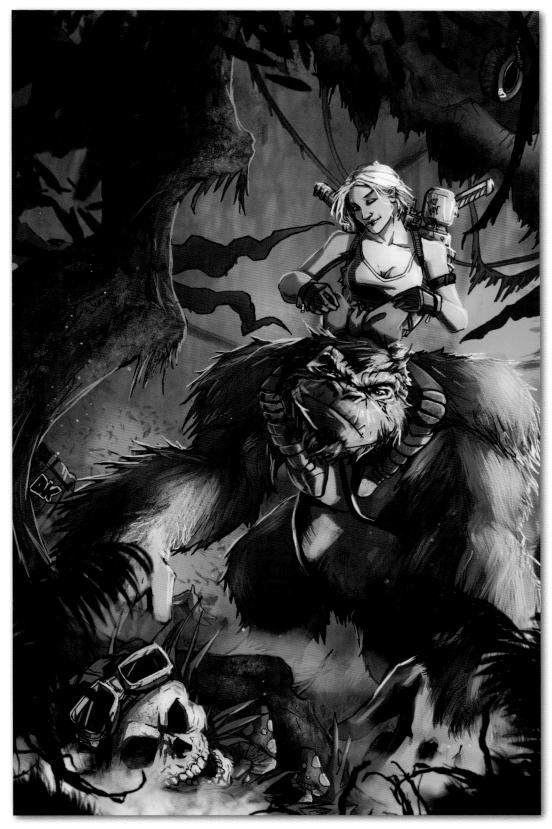

Ambient light

Ambient light greatly affects the colours in an image. Consider how the light from an orange sunset makes everything it touches look different. You can replicate ambient light effects by using a photo filter layer in Photoshop. In this image, the ambient light is the cold blue of the forest, which gives all the elements not touched by reflected light a dark blue hue. The light from behind the subject makes the focal points appear to pop forwards in the illustration. The colour temperature contrast ensures that the woman and the gorilla are the first things to which our eyes are drawn.

Establishing Mood with Colour

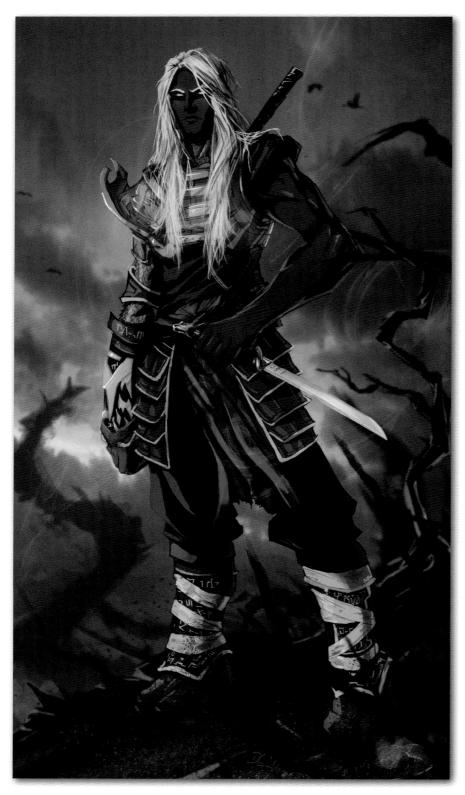

Careful consideration of your colour scheme will benefit your artwork immensely and alter its mood.

Colour qualities

Colours have symbolic meanings and can exert a powerful influence over mood. For example, light blue can give a feeling of calm and tranquillity. Dark blue adds an air of mystery and intrigue. Yellow is bright and optimistic, while red often implies excitement or danger. When choosing a colour scheme, you can either work within your traditional expectations of colour or subvert them to achieve an unusual result.

Colours are also associated with temperature. For example, blue and purple will make a scene look cooler, while red and orange will make it warmer. Warm colours appear closer to the viewer, while cool colours make that part of the image recede. Often a combination of warm and cool colours helps you to achieve a feeling of depth in an image.

Here the character is coloured in purple to add an air of mystery. His bright red sash suggests violence and blood. A red tint overlaying the image hints at his dangerous personality.

Local colour

Another factor to consider is local colour. When a light source is strong, it will affect the colour of the surrounding elements, tinting everything with its hue. A useful trick is to apply a 'Photo Filter' layer in the 'Layers' palette; this will give a soft overlaying colour to unify all the elements in an image, creating a cohesive scene.

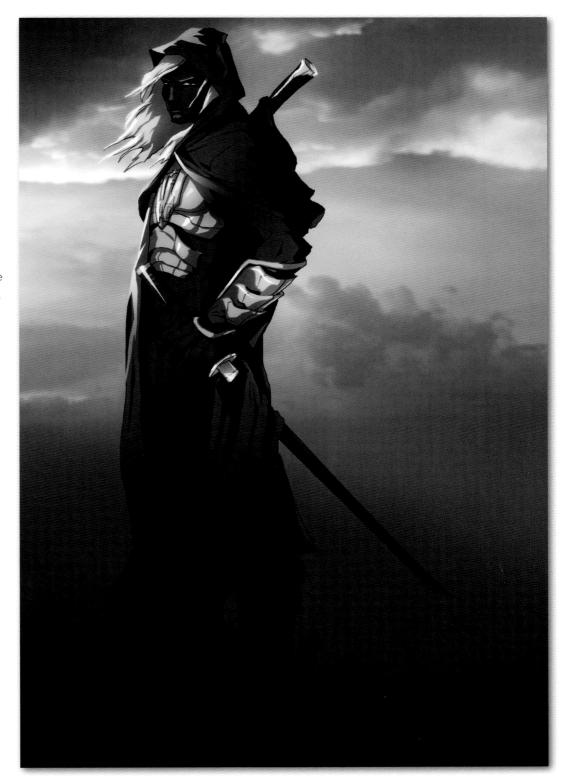

Here is the same character, but rendered with a blue-tinted palette. This creates an enigmatic mood which invites the viewer to guess the character's motivation.

With traditional media, you are committed to your colour scheme. One of the best things about working digitally is that you can use Photoshop to add a colour layer to test out different moods, without undoing any of the work you have done already.

Drawing Faces: Proportions

Although we all have different facial features there are simple guidelines that all faces follow. You can draw these basic head proportions on paper and scan them in when you are ready to develop your drawing or you can draw your head from scratch on the computer, as I have done here. As soon as you've learned the proportions you'll be able to draw all sorts of characters!

 □ Create a new layer to draw your rough guides. Using a blue-coloured brush, start by drawing an oval, then draw a line down the middle. Now make a horizontal line halfway down the oval to create an eye line.

Draw another line halfway between the eye line and the bottom of the oval (the chin) to mark the base of the nose. Finally, draw a line between the nose and the chin that's almost halfway, but slightly closer to the nose.

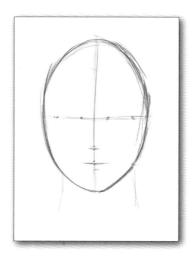

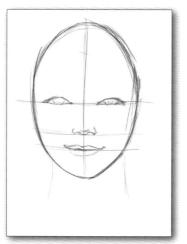

✓ With your guides in place, start to rough out the features, starting with the eyes and mouth. Note that the distance between the eyes should be the width of one eye.

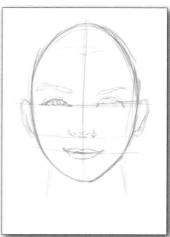

☐ Starting at the eye line, draw the ears by curving slightly upwards before drawing downwards and finishing on the nose line.

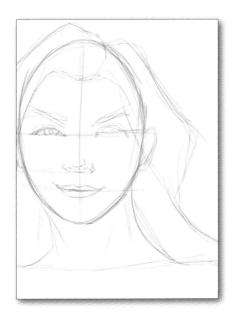

 \triangle Now the basic proportions of the head are in place, you can develop your character in any way you wish. Add details to suggest personality, such as hairstyle and neck posture. Here I have repositioned the head slightly off centre so that the composition is more interesting (remember, asymmetry is always best for composition).

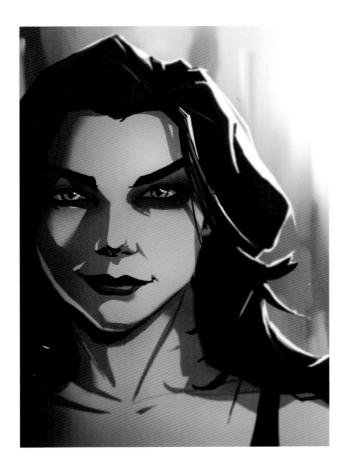

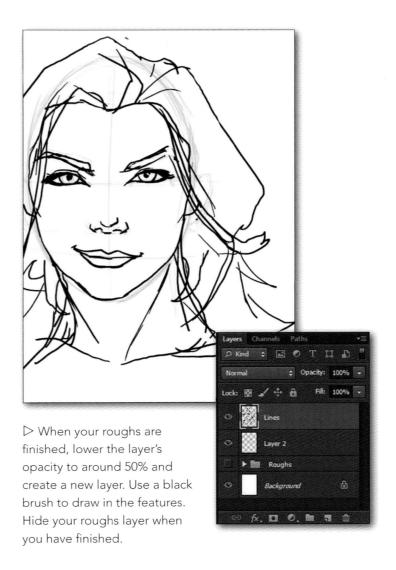

 \triangleleft Now you're free to have fun and colour in the face!

TECHNICAL TIP

While the rules for the facial proportions apply to both men and women, there are some differences you should remember. Generally a male face should have a reasonably broad jaw, while the jaw of a female face should taper in more smoothly towards the chin. The male forehead is usually more prominent than the female's, with a higher hairline and with the eyebrows thicker and closer together. Women's eyelashes should be longer than men's.

Drawing Bodies

Although body size and shape are variable, it is worth following certain guidelines to make sure your characters appear in proportion, much as you would when drawing faces.

Ideal proportions: male

Vertical proportions

For artistic purposes, the typically proportioned adult stands at eight heads tall, with various anatomical details located along the horizontal divisions of each 'head'.

Anatomically, the average adult human measures between six and eight heads tall, but to create appealing images it is acceptable to aim for the higher end of this scale. Most artists will exaggerate human proportions to at least eight heads tall, as this improves the aesthetic value of the image without making it looking unnatural. Fashion and super-hero illustrators tend to use eight-anda-half heads and nine heads respectively. Men and women are drawn using the same head/ height ratios, but women appear shorter as their heads are slightly smaller.

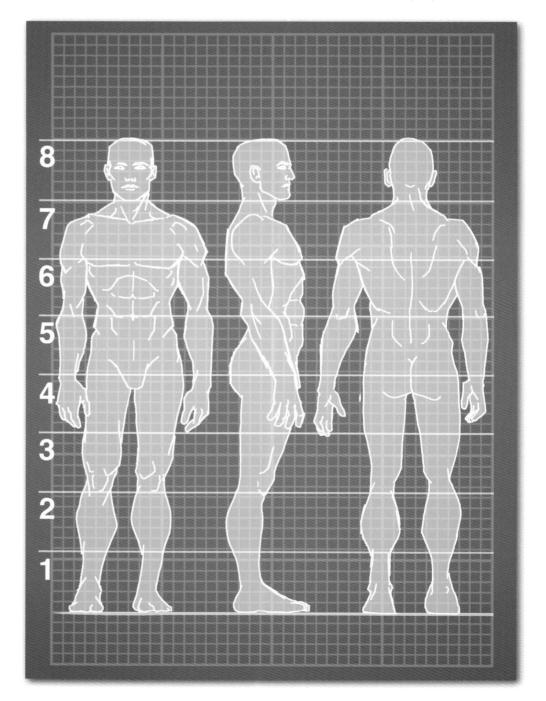

Ideal proportions: female

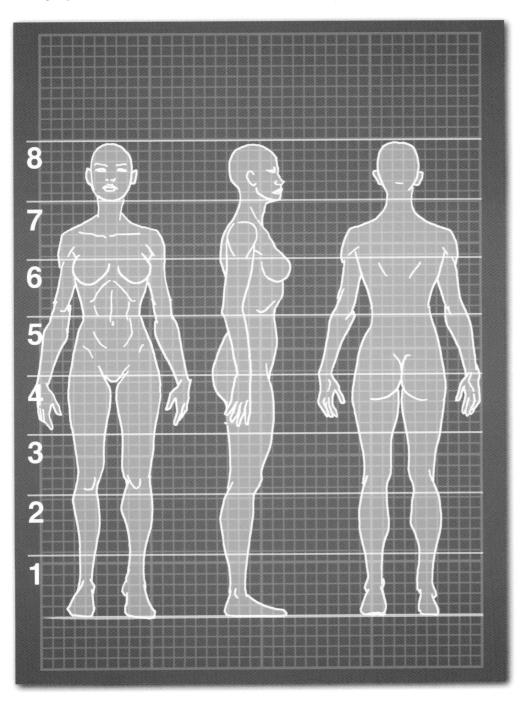

Horizontal proportions

Although men and women share the same vertical proportions, their horizontal proportions differ considerably. A woman's shoulders are narrower than a man's, but her hips are wider. Stylistically it is usual to draw men with more angular lines than women, who are often drawn in a way that emphasizes their curves.

Contrast

Successful image-making often comes from using contrasts that provide interest for the viewer's eye, for example, setting light against dark, warm against cool, or textured against smooth. The major contrast in an image should be located at the centre of interest.

Light versus dark

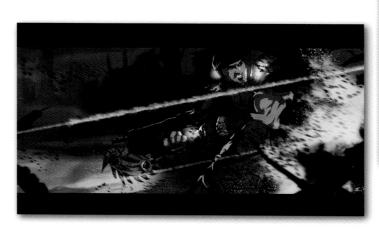

Patterned versus plain

Intense versus muted colours

Organic versus geometric shapes

Large versus small elements

Elements in an image should be part of a hierarchy. If all the elements on a page look the same, the artwork will resemble a child's drawing, where rules such as perspective aren't observed. It is important to remember that the largest objects in the hierarchy are generally not the focus of interest.

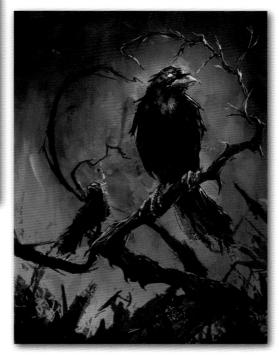

The contrast in this image of birds is created by using cool values for everything apart from the red crow in the foreground. The only area of high colour saturation is in the crow's eye and face. The busy brushwork of the background creates a feeling of frantic movement which contrasts with the stillness of the birds and hints at their menace. The tension of the image would not exist if the birds were rendered in the same busy brushwork as their surroundings.

Drawing Dynamic Poses

A strong, dynamic pose tells a story. The key to drawing a good pose is to make it readable at a glance. To achieve this, all poses should be drawn as clearly as possible.

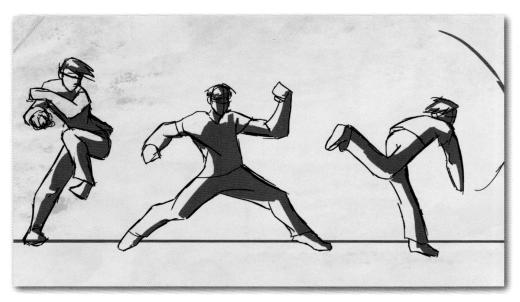

Beginning and end Either focus on the very k

Either focus on the very beginning of the action (the wind-up to throwing a ball, for example) so that the viewer engages by anticipating what is going to happen, or focus on the climax of the action (for example, when the ball has been thrown) so that the viewer will imagine what has just happened. Gestures at the start or end of an action are easily identifiable, but the midpoints are usually unclear and hard to picture.

Strong pose

Weaker pose

Strong pose

Silhouettes

A useful test for the strength of your pose is to draw it in silhouette. If you can work out what it is just by looking at the outline, then you can be confident it will be a strong finished image.

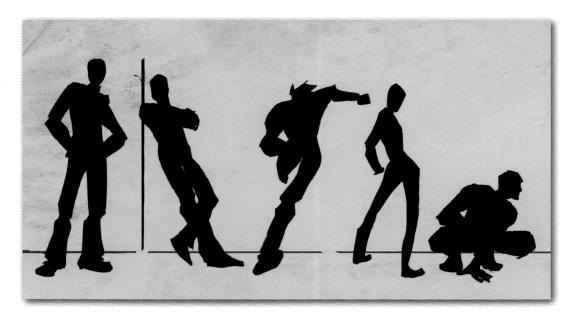

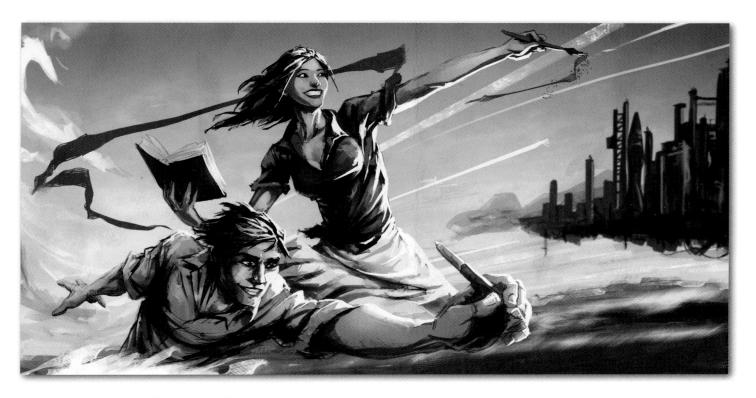

Exaggeration

Another trick to creating a successful pose is exaggeration. Your illustrations should be larger than life, much like a stage actor's performance. Try to draw poses that are filled with motion and even distortion – they will create much more impact than a static, realistic image.

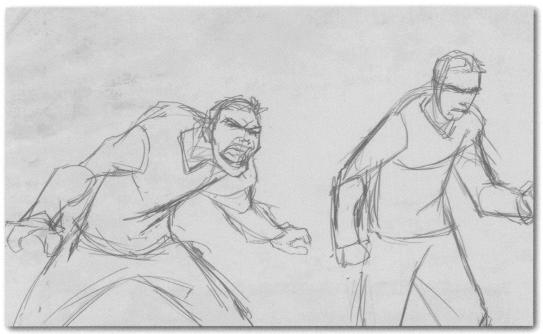

If you want to convey anger, don't draw a character just looking annoyed - draw him or her yelling! You should instantly be able to recognize the emotions a character is experiencing simply by looking at the pose. In the picture (left), the character on the right is clearly annoyed. The pose is 'OK', but you should never aim just for OK with your artwork. The guy on the left is clearly furious; there is no mistaking his mood. The movement and tension in this drawing makes for a high-impact image.

The Rule of Thirds

Deciding on the composition of your image can be tricky. A helpful tip is to use the rule of thirds.

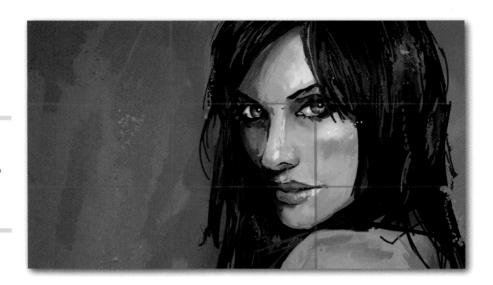

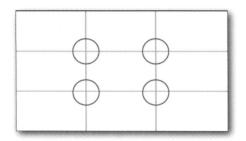

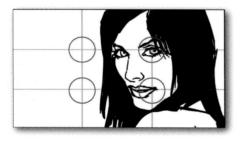

First, create a new layer in your image to act as a guide. Using a brush, divide the image into thirds vertically, then into thirds again horizontally. You can either use Photoshop to add new guides at 33% and 66% or draw them roughly by eye. Lower the opacity of the layer so that you can just see the lines faintly to ensure they don't interfere with your rough drawing. The four points at which the lines intersect are where the focal points of your image should be.

In close-up shots, the focal point is usually the eyes of a character. In wider shots, the focal point is usually the character's face.

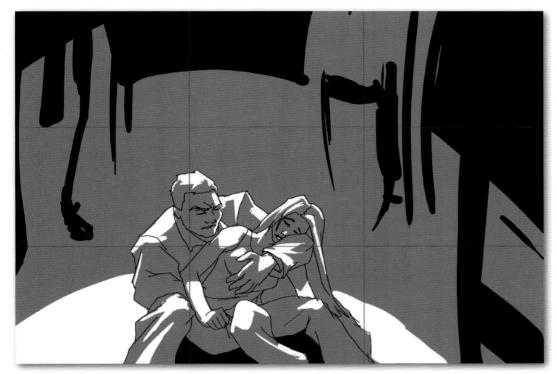

You will find that you mainly use the top two focal points in the rule of thirds. The bottom two are useful for conveying the essence of scale and setting, or suggesting a sense of oppressive weight bearing down on a character.

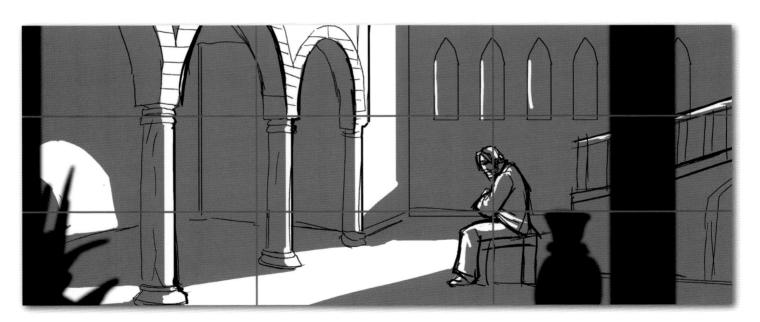

Positioning focal points based on the rule of thirds intersections is a useful trick. This is because, as viewers, we have been subconsciously influenced by paintings, film and TV for years, so we instinctively know where the artist wants us to look in the frame.

Chapter Four:

Digital Art in Action

Now that you understand how Photoshop works and have learnt to apply your artistic knowledge, it's time to try some exercises. These will show you how to achieve certain effects and styles digitally and help hone your skills as a digital artist.

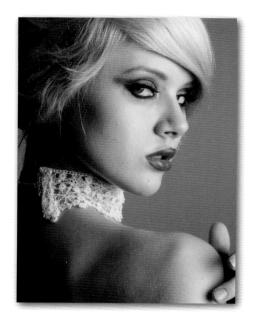

Retouching a Photo in Photoshop

Retouching photographs has become so commonplace in magazines, adverts and films that 'to Photoshop' is now used as a verb in the English language! Retouching a photograph requires restraint. The test of a good retouching job is if it is difficult to see whether anything has been done. Whenever retouching a photograph, always duplicate it (press Ctrl + J) to avoid working on the original.

Step 1 ⊳

First select the *Spot Healing Brush* (press J) to remove any small spots or imperfections. By clicking once over the area you can get Photoshop to sample the colour around it; Photoshop will then intelligently correct the blemish. Increasing or decreasing the size of your *Spot Healing Brush* makes it more effective.

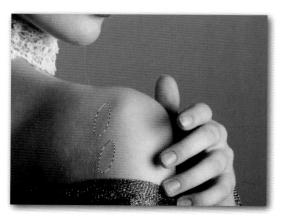

Step 2

If you are trying to remove a blemish or hair that is too close to a neighbouring object (for example, very fine hairs on the shoulder in this photo), switch to the *Patch Tool*. Draw around and select the area you want to modify, then click and drag from the selection to an area of unblemished skin.

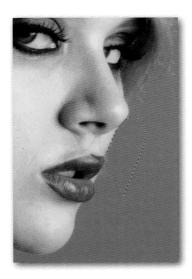

√ Step 3

In this image, there are a few very fine hairs that look untidy against the background. Neither the *Spot Healing Brush* nor the *Patch Tool* will work well here because the model's face is too close to the area we need to focus on. Instead use the *Lasso Tool* carefully to select the area you want to edit and the *Clone Stamp Tool* (press S) to replicate the background up to the model's cheek. Press and hold Alt, then click your cursor to define the area you want to clone from. You'll need to clone from an area close to the bit you are working on to make sure the background matches.

Step 4 ⊳

Tidying up the stray hairs around the model's neck is easily done. Use the Lasso Tool to quickly trace round the noticeable strands of hair. Press Shift + Backspace to bring up the 'Fill' dialog box. In the 'Contents' drop-down menu select 'Content-Aware'; Photoshop will fix the problem for you in the same way it did with the Spot Healing Brush.

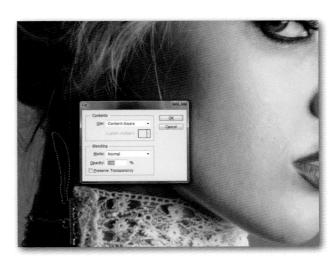

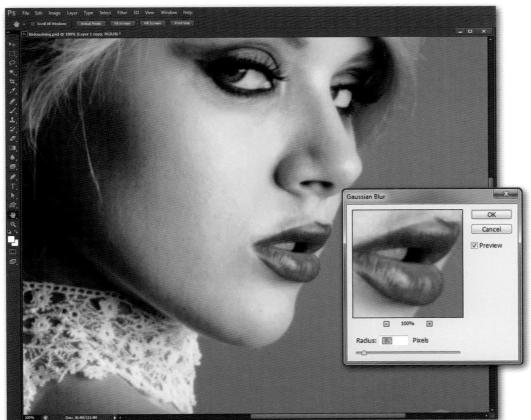

Step 5

When you have finished working on the skin, apply a small *Gaussian Blur* to even out the model's complexion. This will reduce the detail of the pores without obliterating them entirely. You have to be careful not to make the skin too smooth or else it will look like an obvious retouch.

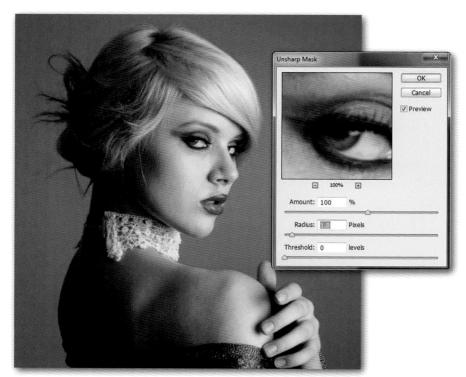

√ Step 6

Apply the 'Unsharp Mask' filter (go to Filter>Sharpen>Unsharp Mask) and set Amount to 100% and Radius to 1.0 pixels to slightly reduce the impact of the Gaussian Blur.

Step 7 ⊳

To boost the fairness of the model's skin, add a 'Curves Adjustment' layer. Near the middle of the line in the 'Curves Properties' dialog box, drag directly up to lighten your image slightly (the amount you need to drag will vary depending on the lighting of your photo). Press Ctrl + I to invert the curves mask, hiding the brightness, then use a soft airbrush to paint on the layer mask, bringing the lightness back in onto the skin only.

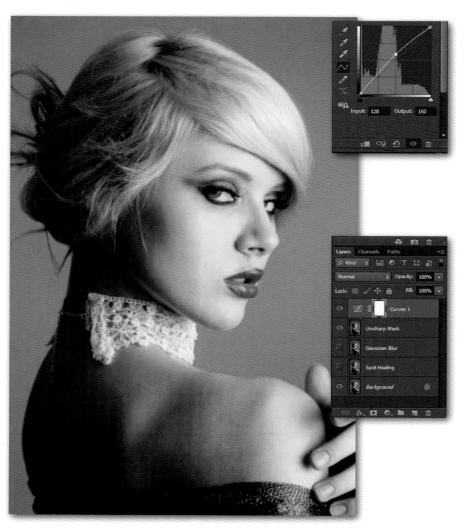

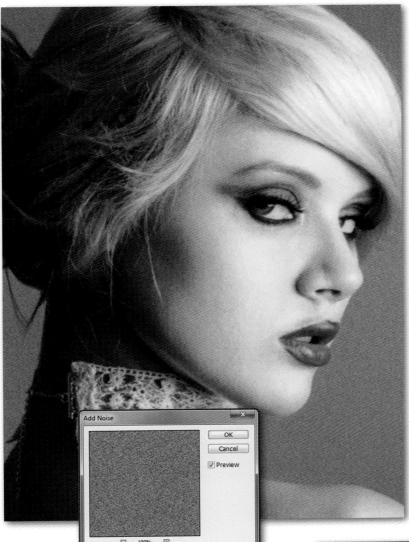

Step 8

Now go to Filter>Blur>Gaussian Blur and apply a small blur (between 2.5 and 15 pixels, depending on your image) to smooth the skin, removing most of the uneven pores. Again, don't use too much blur – you don't want the image to look unnatural.

For the fake, smoother pores on the model's face, create a new layer with the blending mode set to Overlay. Check the box Fill with Overlay – neutral color (50% gray). Now go to Filter> Noise>Add Noise and set Amount: 10%; Distribution: Gaussian. Ensure that 'Monochromatic' is checked.

Step 9 ▷

Amount: 10
Distribution
Uniform
Gaussian
Monochromatic

Apply a Gaussian Blur of 0.5 pixels to soften the noise. Lower the opacity of this layer until it looks convincing as a skin texture. This noise layer will simulate skin pores but in a much more pleasing, even way, while the digital grain will stop everything looking too smooth and processed.

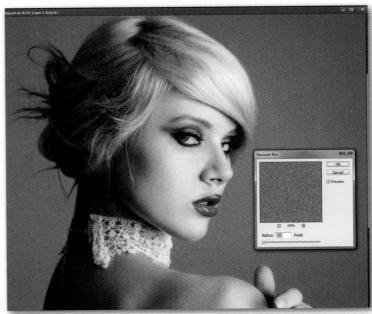

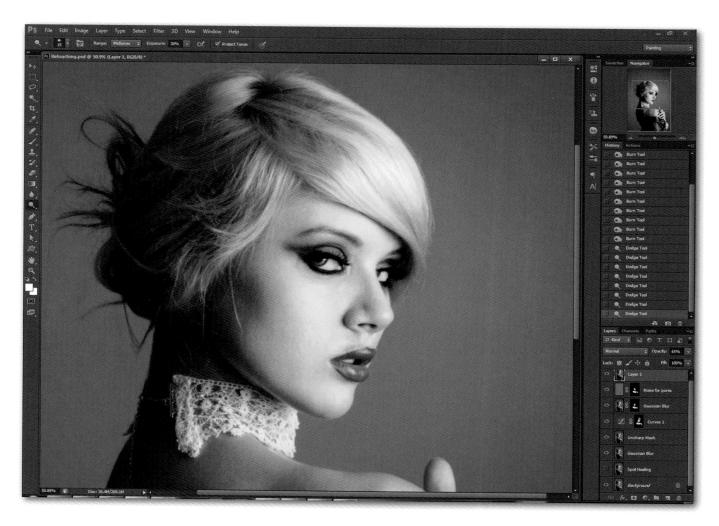

\triangle Step 10

Press Ctrl + Alt + Shift + E to create a copy-merged duplicate of the image and select the *Dodge Tool* (press O) with the following settings: *Hardness, 20%; Range, Midtones; Exposure, 30%.* Check 'Protect Tones'. Use the *Dodge Tool* on the model's eyes, lips and teeth to brighten them. Be careful not to overbrighten the whites of the eyes, because one of the tell-tale signs of photo retouching is when these are unnaturally bright and almost glowing!

Step 11

Switch to the *Burn Tool* (in the *Dodge Tool's* fly-out menu, or press Shift + O) with the following settings: *Hardness, 15%; Range, Shadows; Exposure, 15%.* Use this to darken the model's eyes, eye-shadow and eyelashes. Lower the opacity of the layer to around 65% (depending on your photo) to make the effects subtler.

Step 12 ⊳

Finally, press Ctrl + Alt +
Shift + E to create another
copy-merged duplicate of
the image. Set the layer's
blending mode to Soft Light
with the opacity lowered
to around 31% to boost
the colours.

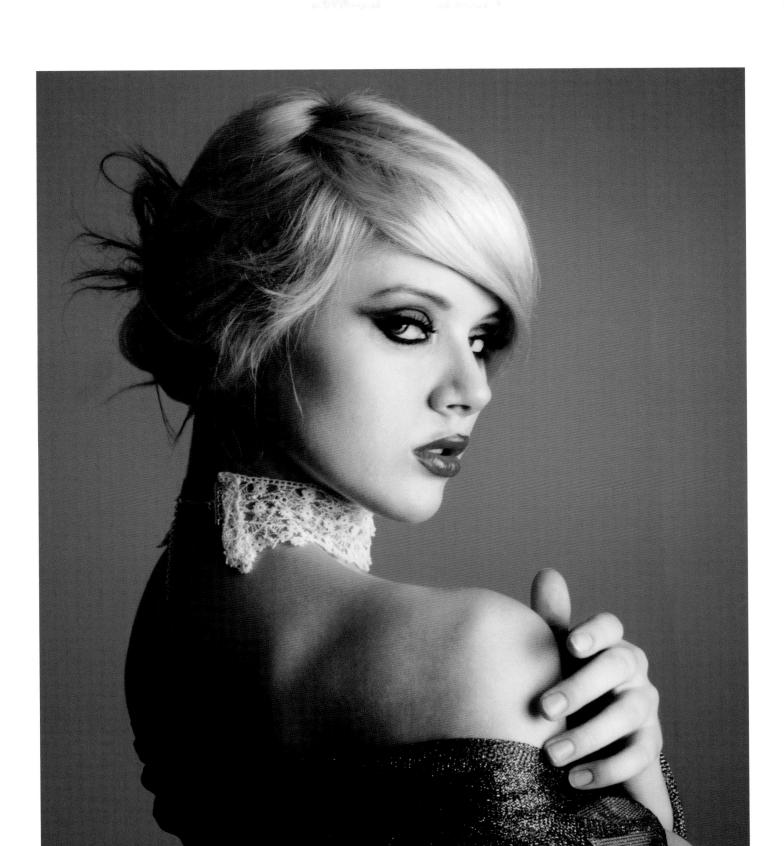

Retouching a Photo in Photoshop // 71

Oil Paint Effect

Achieving an oil paint effect in Photoshop is tricky. Although Photoshop CS6 has an oil paint filter and Photoshop CS5 can use the downloadable *Pixel Blender Tool* from Adobe Labs (see page 128), these options aren't ideal and leave a rather obvious 'filter effect'. This exercise shows you how to use the 'Oil Paint' filter and *Mixer Brush* to create a digital oil painting from a photograph.

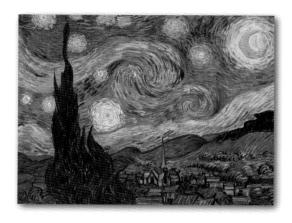

Step 1 ▷
Start by selecting your photo. An image showing the sky with clouds will form the basis for a digital artwork inspired by Vincent Van Gogh's famous painting Starry Night (above).

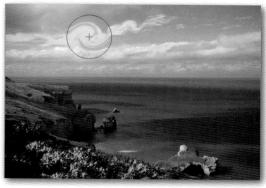

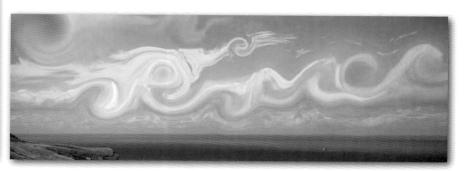

 \triangle Step 2

Go to Filter>Liquify and select the Twirl Clockwise Tool (press C). Click and hold your cursor over the clouds and watch as Photoshop starts to warp them in a spiral. You can even drag the twirling cursor to distort things further. When your clouds are sufficiently stylized, click OK.

Step 3 \triangledown \triangleright

Duplicate the layer by pressing Ctrl + J, then go to Filter>Oil Paint. (If you're using an older version of Photoshop go to Filter>Pixel Blender>Pixel Blender Gallery and select 'Oil Paint' from the drop-down menu).

The 'Oil Paint' filter will produce different results for each photo, so you will have to judge the effects of these sliders by eye. To create a pastiche of *Starry Night*, I've made the *Scale* large and opted for very noticeable effects. We want to be able to see as much detail as possible in the fake brushstrokes.

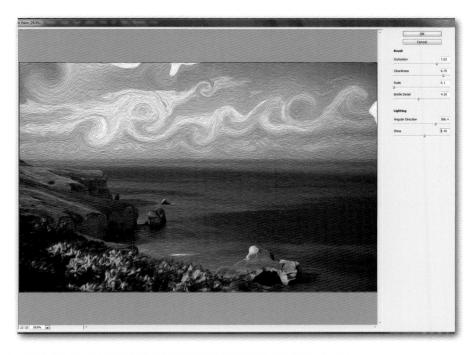

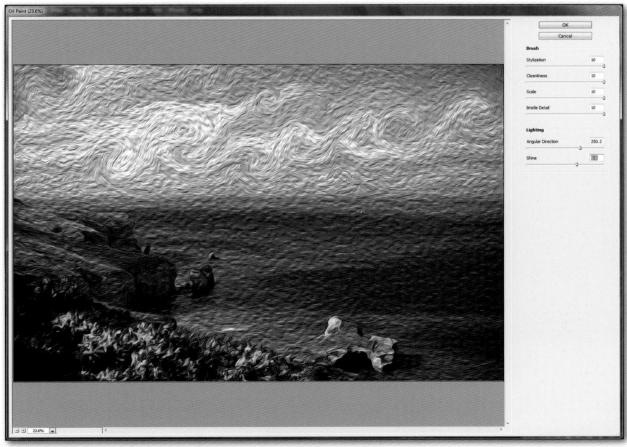

Step 4 ⊳

The canvas weave automatically appears as part of the 'Oil Paint' filter. I'm generally happy with how the filter looks, but the effect is a bit strong (everything looks as though it has been run through the 'Emboss' filter). To help with this, I've duplicated the original photo layer, dragged it above the filter layer and reduced the opacity to 25%, so that it very slightly masks the embossed quality of the filter layer.

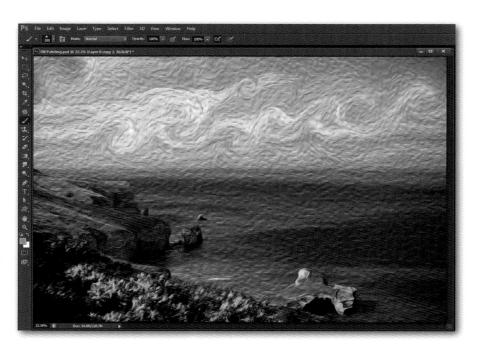

∇ Step 5

To paint some extra features into the image, create a layer called 'Additions'. Use a custom brush of your choice to paint a dark tree in the foreground, making it very curvy and stylized. With the same brush, trace around the edges of the landscape to create outlines; use the darkest local colour available for each area. Add some more defined swirls to your sky, if necessary.

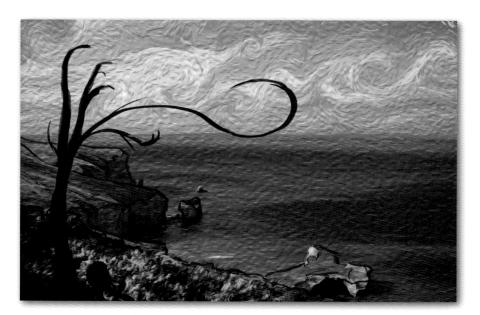

Step 6 ▷

Create a new layer called 'Mixer Layer'. Select the *Mixer Brush* (found in the brush flyout menu or by pressing Shift + B). Use a *Round Curve* brush (selected from the 'Brush' tab) with settings that match the screenshot. Ensure that 'clean the brush after each stroke' is unselected in the *Options Bar*, so that the brush continues to pick up paint with each brushstroke you make. Check the 'Sample All Layers' box.

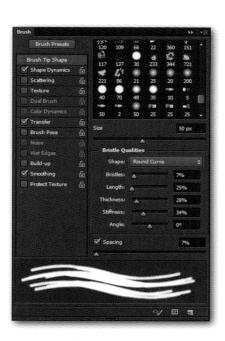

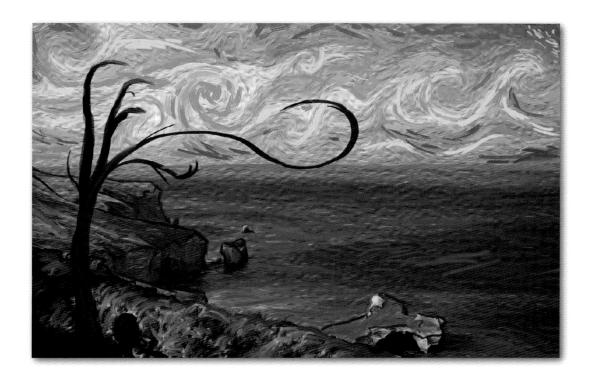

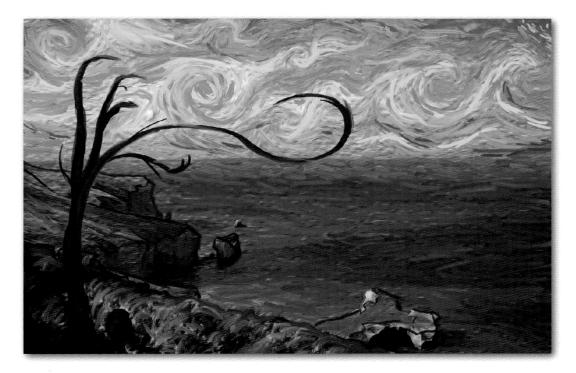

 \triangle Step 7

The beauty of using the *Mixer Brush* is that you can paint non-destructively. You can use paint from all the layers, but the brush marks you're putting down will be on a unique layer so that everything underneath it is safe and unharmed.

Apply your paint using fairly large brushstrokes, moving your brush to match the shapes in your photograph. The 'Oil Paint' filter has provided a good base image on which to work; if you set the *Mixer Brush* to 1% wet it will constantly pick up colours underneath, so all you have to do is move your brush around, effectively cloning paint from the image beneath.

∇ Step 8

Occasionally you will have to use the *Colour Picker* to avoid the paint on your brush interfering with the area you are colouring. In this instance you need to use a blue to paint over the sea, because the white from the clouds would influence the *Mixer Brush's* strokes too much.

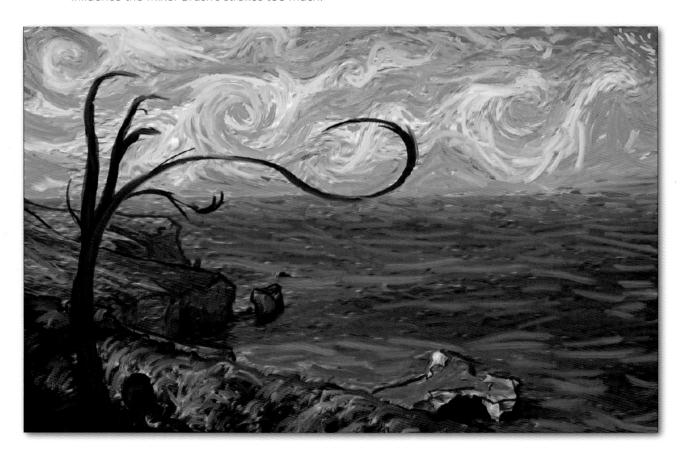

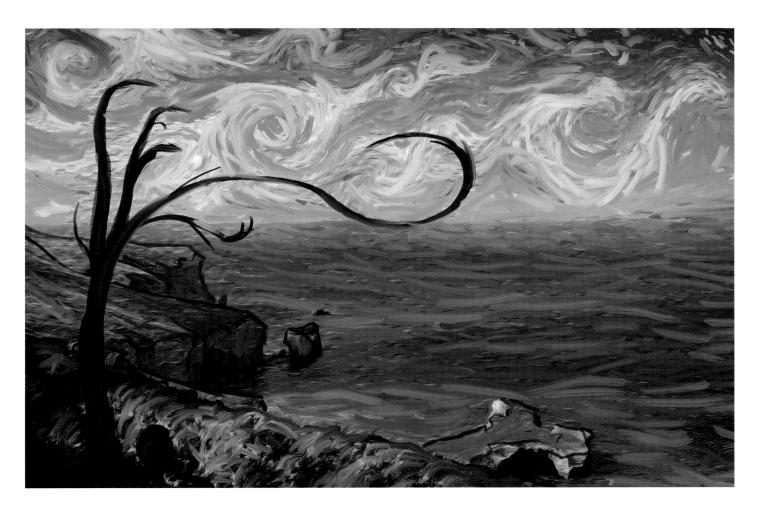

For a finishing touch, add a new layer with the blending mode set to Overlay to boost the colours of your painting. Use the Linear Gradient Tool, set to Foreground to Transparent, 25% opacity, to apply some dark blue gradients to the top of the sky. Change to the Radial Gradient Tool and use a pale blue colour to apply multiple small gradients to the lower portion of the sky. Now pick a highly saturated yellow to apply to the foreground of the image.

Watercolour Cloning in Photoshop CS6

Watercolour cloning allows you to make painterly strokes by sourcing them from an existing photo. For Photoshop CS6, artist Tim Shelbourne and Adobe's Russell Brown have devised an excellent method of watercolour cloning that looks convincing and can be achieved with just a little practice. They have incorporated this into a new Adobe Watercolour Assistant panel that you can download for free from the internet (see page 128).

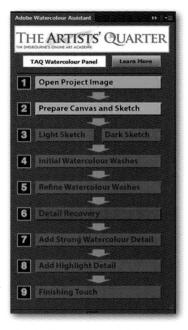

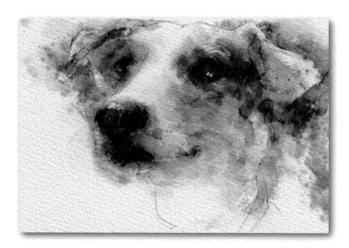

This section covers the basic tools supplied with the Watercolour Assistant. However, if you click on the link to the Artists' Quarter (http://theartistsquarterblog. com) in the Watercolour Assistant panel you can study Tim Shelbourne's more advanced techniques online.

Once you've downloaded and installed the Watercolour Assistant panel, it will take you through the process of constructing your watercolour painting from a photograph. With each step you select, it will run a script that automates various stages of the procedure. This means that you can focus on painting and not worry about getting the layers laid out correctly.

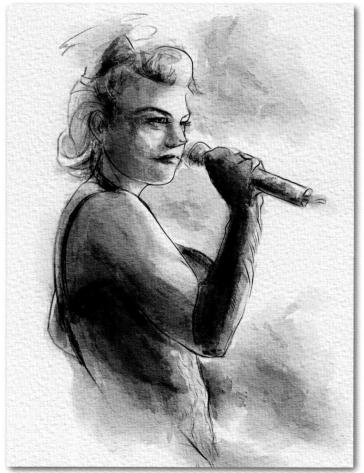

Step 1 ▷

Once you have selected your photo, you'll need to prepare it to get the best result. Go to Image>Adjustments > Vibrance and boost the vibrance and saturation levels with the sliders. Make them much higher than you would when editing a photo in the usual way.

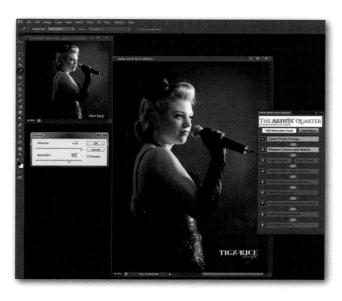

PS for Gill longs large last film 20 dos stream to get a base for get a base for

Step 2

Next go to Image>
Adjustments > Curves
and boost the contrast
significantly by dragging up
on the point shown in the
white area of the 'Curves'
dialog box (as indicated
in the screenshot). Move
the point in the dark area
down slightly.

Step 3 ⊳

Now that your photo is prepped, click on Step 2 of the Watercolour Assistant panel. It will prepare your canvas and automatically generate a pencil sketch from your photograph. In Step 3 you can choose between a light or a dark sketch, depending on your needs. The script always creates a light and a dark sketch layer, so if you change your mind later you can just hide or reveal the dark sketch layer in the 'Layers' palette.

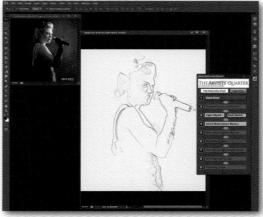

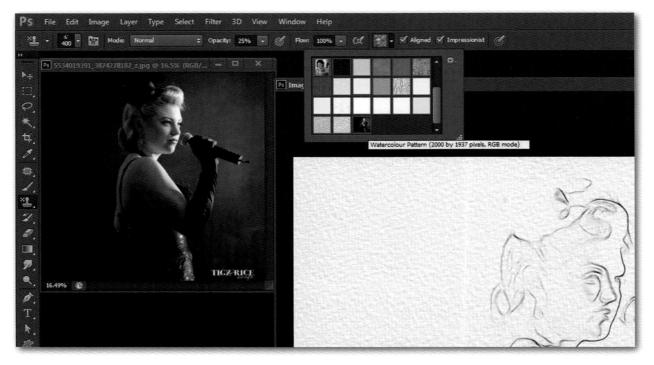

Next click Step 4 in the Watercolour Assistant panel, 'Initial Watercolour Washes', to create a clipped vibrance layer (in case you want to edit the vibrance at any point). Then go to the *Pattern Picker* in the *Options Bar* and choose the watercolour pattern of your painting. It will always be the last pattern of the set (the script will have generated it for you automatically).

Step 5 ▷

You will find that you now have the *Pattern Stamp Tool* with a custom brush selected. Use this brush to paint loosely in the first layer. It's important to keep your stylus pressed down as you trace out the colours on the page, as the brush has a multiplying effect and will get darker each time you apply it. The *Pattern Stamp Tool* will have the 'Impressionist' option checked; this means you will get a loose interpretation of the colours from the photo beneath, which adds to the watercolour feel.

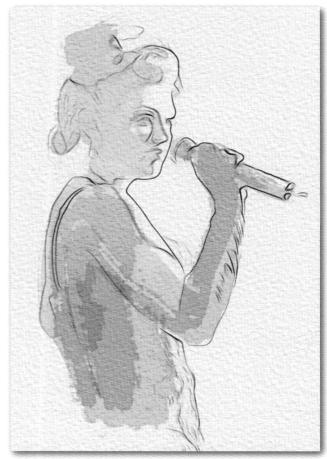

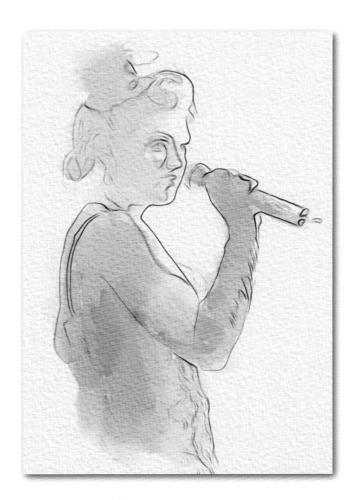

When you've finished laying down the first wave of colour, switch to the *Smudge Tool*. Using a messyedged custom brush, smooth out the edges of the paint to make it appear more diffuse, as though it is bleeding out with too much water. It's important to remember that to run the script correctly you must switch back to the *Pattern Stamp Tool* (press S) before moving on to another stage of Watercolour Assistant.

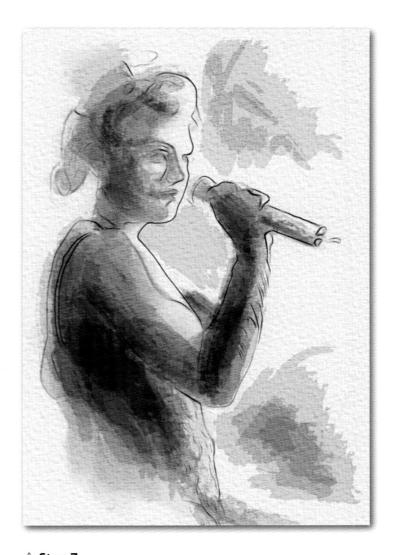

\triangle Step 7

By clicking on the next stage of Watercolour Assistant you create a new layer and a resized *Pattern StampTool*. You use this for the most important aspect of the image – to build up tone and colour. Remember to leave the areas of strong highlights unpainted to reflect the watercolour style. From this stage on, it's important to reference the original photo for the best effect, so either have it open in your workspace or on a separate monitor if you have one.

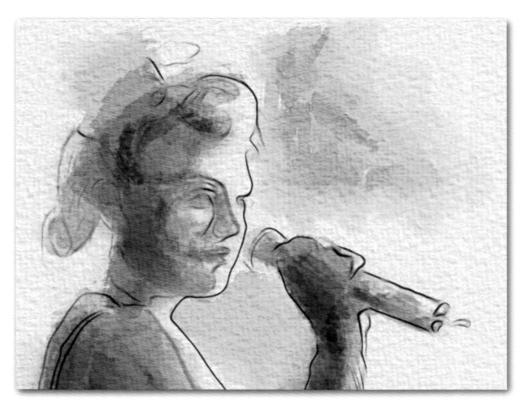

 \triangle Step 8

When you have finished painting these larger amounts of shading detail, switch to the *Smudge Tool* again to even out some of the paint. Modify the edges to make the paint bleed outside them a little.

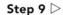

Now for the 'Detail Recovery' stage, where the brush selected is smaller. It will pick up details from the photo without the 'Impressionist' option selected; this makes it more accurate. Paint over the focal points with fairly small strokes. Then smudge these painting strokes so that the lines are less defined.

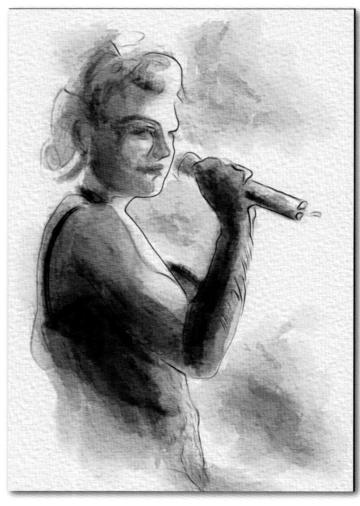

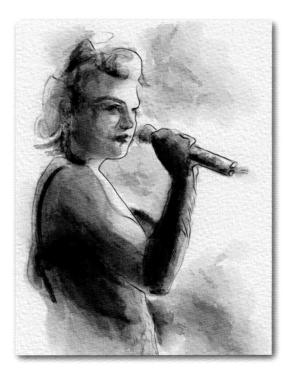

This is the 'Strong Watercolour Detail' phase, where the brush you use to clone produces maximum detail, colour and tone. Use it sparingly, and only over the main focal points, or it may damage the watercolour effect.

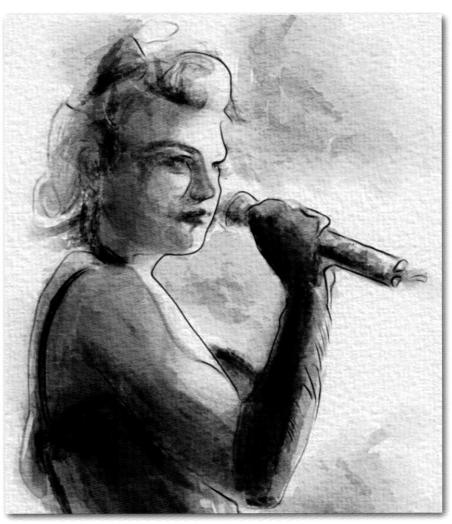

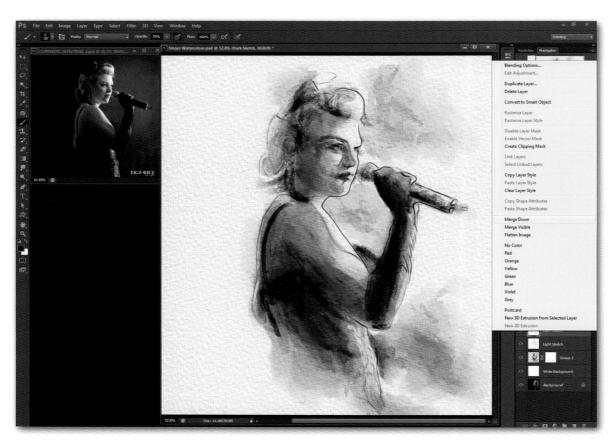

Before you move on to the final stage of Watercolour Assistant, go to the light and dark sketch layers and unlock them by clicking on the padlock icon. Press Ctrl + E to merge them down into a single layer, then press B to select a pencil brush and add any lines you need to achieve a more accurate pencil effect.

Step 13 ▷

Once you have finished adding to the lines, reselect the *Smudge Tool* and use it to fade out sections of the lines. This mimics the way in which graphite dissipates through the repeated application of water.

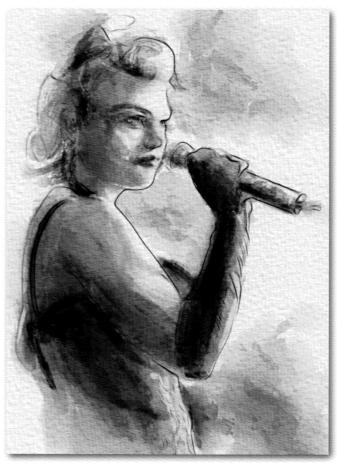

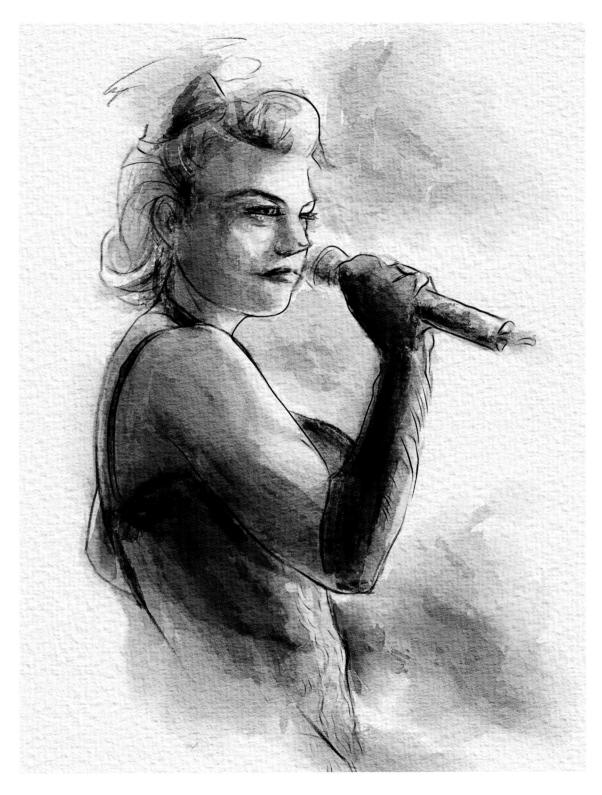

 \triangle Step 14 Reopen Watercolour Assistant and click on Stage 9, 'Finishing Touch', to apply a high pass layer that will sharpen the details and make your painting look crisp.

Silkscreen Print Effect

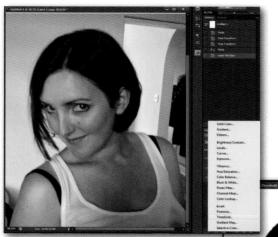

Traditional screen-printing is great fun, but it is time-consuming to do and expensive to set up. It is much quicker and cheaper to create a screenprinting effect in Photoshop.

Step 1 \triangle \triangleright

Copy a photo of your choice into a new A4 document. Duplicate your photo by pressing Ctrl + J. Click the small black-and-white circle in the 'Layers' palette and select 'Threshold' to create a 'Threshold' adjustment layer. Adjust the *Threshold Level* slider until you get a result you like.

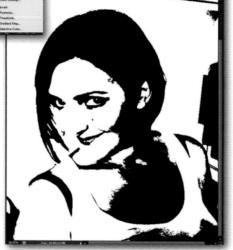

TECHNICAL TIP

If you can't work out
where to make the selection
because the threshold
result has made it unclear,
hide the 'Threshold' layer
by clicking on the eyeball
in the 'Layers' palette. Now
trace round the subject in
the original photo.

Step 2 ▷
Press Shift + L to access the
Magnetic Lasso Tool (set it
to 'Add to Selection' in the
options toolbar) and use it
to trace round the subject of
your photograph.

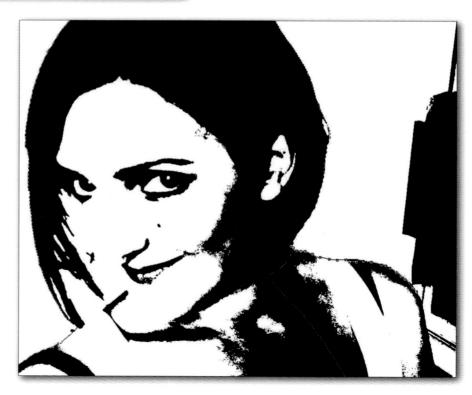

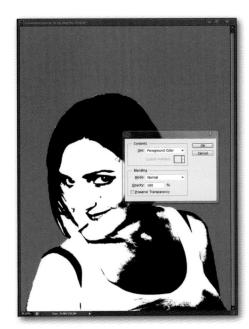

Step 3

When your $Magnetic\ Lasso\ Tool\ selection\ is\ complete,\ press\ Shift\ +\ Ctrl\ +\ C\ to\ make$ a copy of the threshold result. Now press\ Shift\ +\ Ctrl\ +\ V\ to\ paste\ it\ into\ a\ new\ layer. Create\ a\ new\ layer\ underneath\ the\ pasted\ results\ and\ fill\ it\ with\ a\ bright\ primary\ colour\ of\ your\ choice\ (in\ this\ instance\ l've\ used\ red). Now\ hide\ all\ the\ other\ layers.

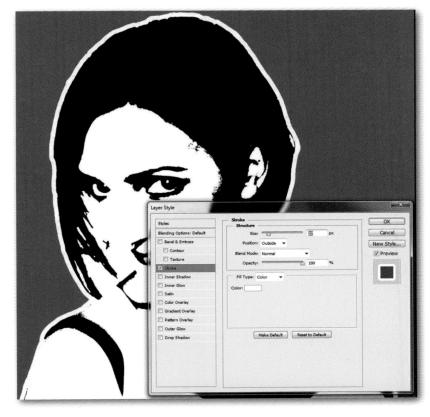

Step 4 ⊳

Add a white stroke border by double-clicking on the pasted layer in the 'Layers' palette to open the 'Layer Style' dialog box. Click Stroke in the left-hand column. Then, in the centre column, set Size, 27 pixels; Position, Outside; Color, white. Click OK.

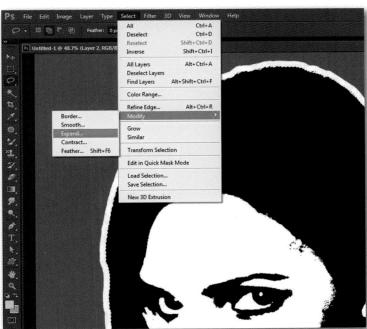

Step 5

Ctrl-click on the pasted layer's thumbnail in the 'Layers' palette to select it. Now go to Select >Modify >Expand Selection; expand by 27 pixels and click OK. Double-click on the Foreground Color Picker and select a light green colour. Then double-click on the Background Color Picker to select a dark green colour.

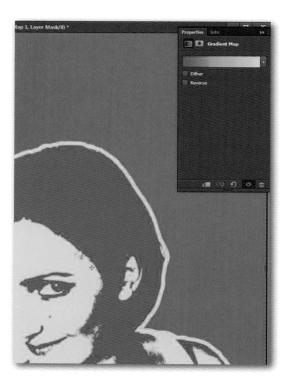

√ Step 6

Now add a 'Gradient Map Adjustment' layer by clicking on the small circle icon in the 'Layers' palette. You'll notice that Photoshop has automatically recoloured the layer based on the two colours you have picked. If the colours are displayed in the wrong order, simply check the 'Reverse' box to switch them round.

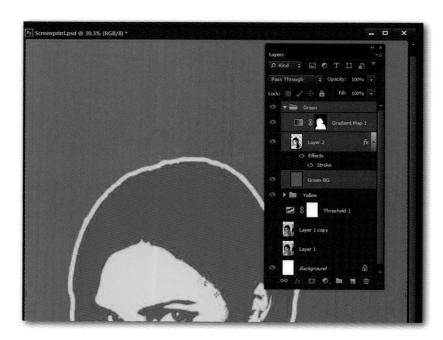

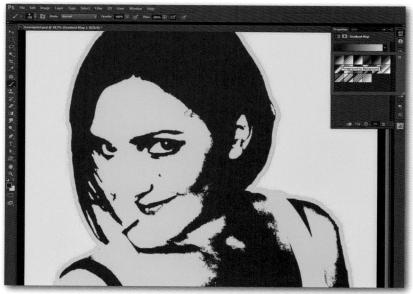

\triangle Step 7

Click on the 'Gradient Map' in the 'Layers' palette. Press Shift, click down to the background colour layer (selecting the layers you've just been working on) and press Ctrl + G to turn them into a layer group. Name the folder and press Ctrl + J to duplicate it. Rename the new folder 'Yellow' and hide the old folder for now.

\triangle Step 8

Hide the visibility of the 'Gradient Map' in the new layer group and fill the background layer of this group with yellow. Now pick light blue and dark purple as your foreground/background colours and bring back the 'Gradient Map' layer. To get the 'Gradient Map' to match the new colours you've selected, click on the 'Colour Gradient' drop-down menu in the 'Properties' tab and select 'Foreground to Background' (the first swatch in the gallery).

Step 9 ▷

Repeat this process to create two more layer groups, colouring them differently each time. Open a new A4 document. Create two guides dividing the document into quarters by clicking View>New Guide. Select Orientation, Horizontal; Position, 50%. Follow this procedure again to add a vertical guide.

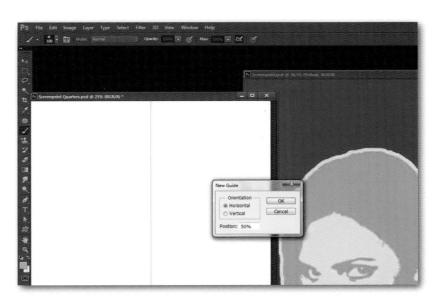

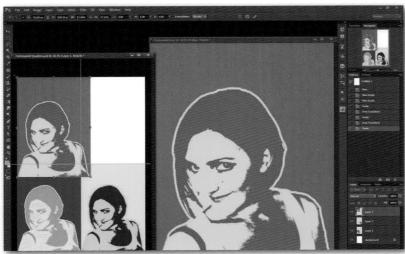

In your previous document, press Ctrl + A and Shift + Ctrl + C to copy from all visible layers of one of the layer groups. Paste this into the new document and free transform it (press Ctrl + T) to shrink it down into one of the quadrants. Hold down Shift while transforming to constrain the proportions. You will find that the 'Transformation' box will snap to the guides you have created.

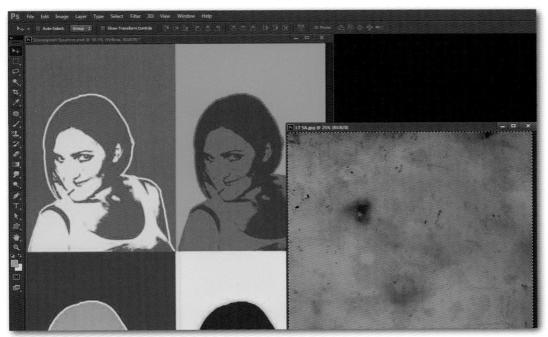

When all four colour versions of the image are pasted in and shrunk down to size, press Ctrl + H to hide the guides. Now open up and copy an old parchment paper texture and paste it over the images in your new document. Set the blending mode to *Overlay*.

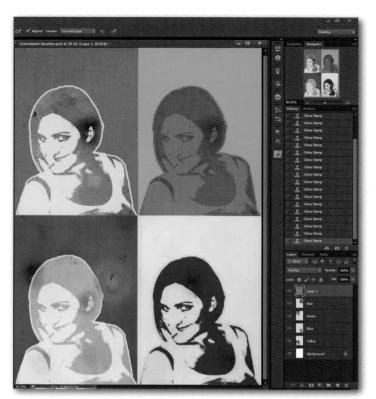

√ Step 12

Press S to select the *Clone Stamp Tool* and use it to clone some interesting bits of texture onto your image. Screen-printing often leaves uneven areas of colour, so cloning darker areas of texture over your subject will help to simulate this effect. When you have finished, duplicate this texture layer, free transform it and right-click over the 'Transformation' bounding box. Select 'Flip Horizontal', click OK, then lower the new layer's opacity to 33% to increase its uneven appearance.

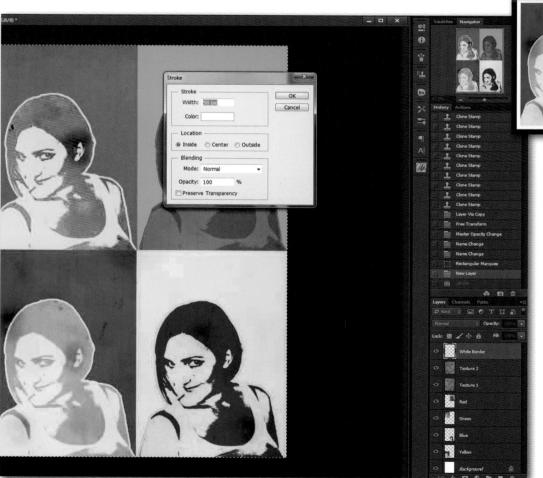

\triangleleft \triangle Step 13

Using the Square Marquee Tool (press M), draw a selection over the entire image, then right-click and select 'Stroke' from the popup menu. Choose Stroke: Width, 50 pixels; Color, white; Location, Inside. Click OK to create a white border round the image.

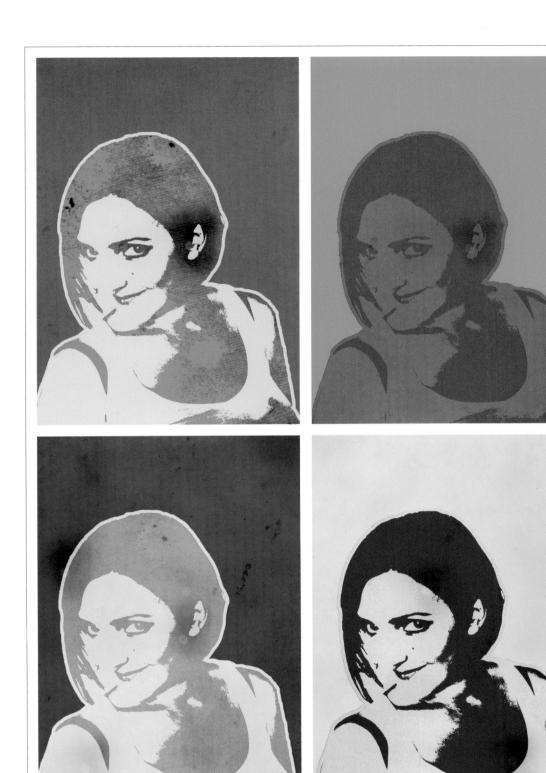

Make a new layer and press Ctrl + H to reveal the guides again. Select a hard-edged brush (press B) and set it to 50 pixels. Move your cursor to where the guides intersect. Press your stylus onto the canvas and hold down Shift to draw lines vertically. The brush will snap to the guides. Pressing Shift will ensure you continue to draw in a straight line. Repeat this action to draw the horizontal lines. If necessary, nudge your images up to fit the new border. Do this by pressing V to access the Move Tool and using the 'Up' arrow key to move each layer into position.

Chalk and Charcoal Effect

For centuries, people have used chalk and charcoal to produce expressive images prehistoric humans even decorated their caves with chalk drawings! Today chalk and charcoal are often used to draw still-life images, as they can lend interest to the most mundane of subjects. In Photoshop, we can replicate the effect of chalk and charcoal by manipulating photographs. As this is a black-and-white medium, try to find a photo with high contrast; it will give the most impressive results.

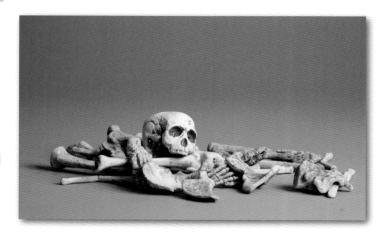

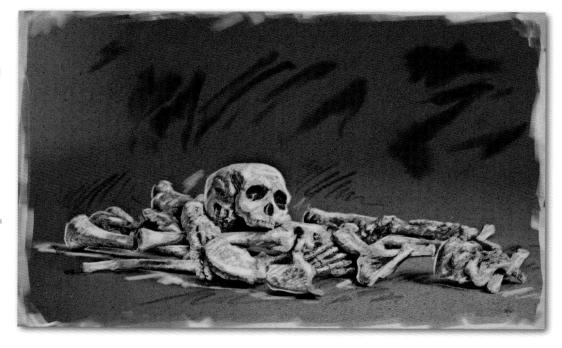

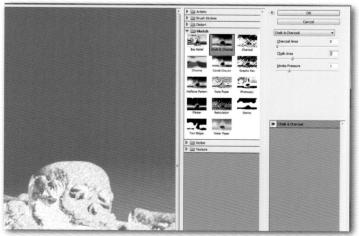

Step 1

Duplicate the photo by pressing Ctrl + J. Now go to Filter>Sketch > Chalk and Charcoal (found in the Filter Gallery in CS6). Experiment with the Charcoal Area and Chalk Area sliders until you get a sufficiently sketchy appearance. The settings will vary depending on the photo you use, but as a rule I'd recommend setting Stroke Pressure to 1. Hide the layer by clicking on the eyeball icon in the 'Layers' palette.

√ Step 2

Duplicate the background layer and press Ctrl + U to access the 'Hue/Saturation' dialog box. Drag the Saturation slider all the way to the left to desaturate the image, then click OK. Duplicate this layer again.

Step 3 \triangleright

Press Ctrl + I to invert the colours of the layer. Change the blending mode to *Colour Dodge* in the 'Layers' palette. This will turn everything white – don't worry, we'll fix this in the next step!

Gaussian Blur OK Cance P Preview Radlus: Description Pixels

√ Step 4

Bring the outlines back by going to Filter>Blur>Gaussian Blur and move the Radius slider to the level you want. You'll need to apply the blur sufficiently to restore some strong blacks, but don't make the level too high or the white will start to obscure all the fine, grey detail.

Step 5 ▷

Press Ctrl + E to merge down the layers and move the merged layer to the top of the layers stack. Change the layer's blending mode to Multiply, then unhide the layer beneath it.

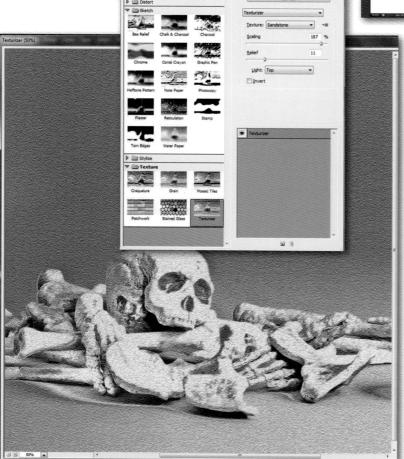

Step 7 ▷

Add a 'Pattern Fill' layer by clicking on the small black-and-white circle in the 'Layers' palette. Choose 'Charcoal Flecks' from the fly-out menu and increase the Scale slider significantly until the 'Pattern Fill' texture is several hundred times larger. Again, judge it by eye to suit your photo.

Step 6

Press Shift + Ctrl + Alt + E twice to make two copy-merged versions of the image. Go to Filter>Texture>Texturizer (or find it in the Filter Gallery in CS6). Select the 'Sandstone' texture and adjust the 'Scaling' and 'Relief' options so that your image looks as though it has been drawn on sugar paper.

Step 8 ▷

Set the blending mode to *Multiply*, then press Shift + Ctrl + Alt + E to make another copy-merged version of the image. You will find that the charcoal flecks pattern repeats too obviously, so press J to select the *Spot Healing Brush*. Use this to remove some of the darker marks that give away the repeat/ tiled pattern.

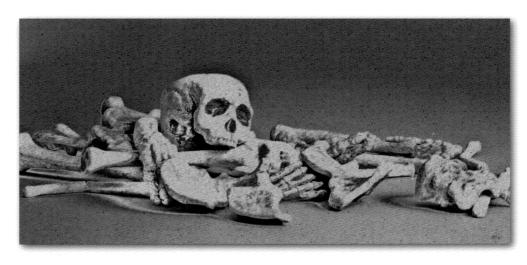

Gallery). All versions of Photoshop

erodible, tipped chalk brush. With vour chalk brush, sketch round

the outlines of the subject. Use

a zigzag motion on the highlight sections, making them lighter, in

much the same way as you would with real chalk. This will make the rendering appear more authentic.

come with built-in chalk brushes;

CS6 has a particularly good,

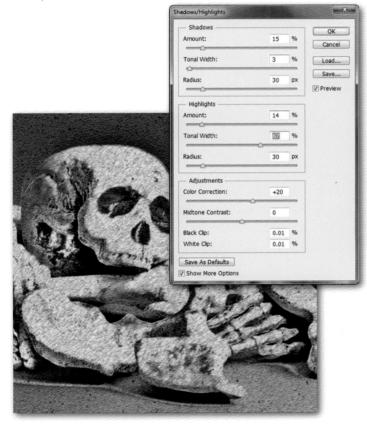

\triangle Step 9

Go to Filter>Adjustments > Shadows/ Highlights and manipulate the Shadows and Highlights sliders in the dialog box, making the shadows darker and the highlights brighter. If you want more refined control over the sliders you can check the 'Show More Options' box.

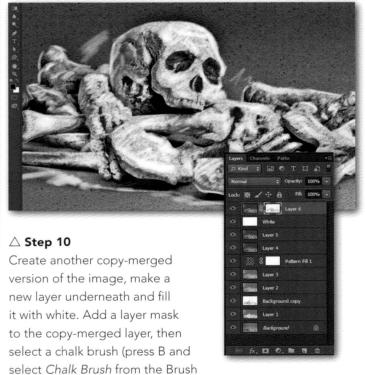

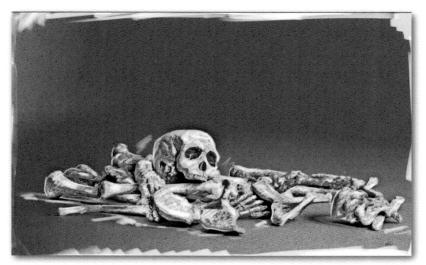

$\triangleleft \triangledown$ Step 11

Use the *Chalk Brush* to paint on the mask of the copymerged layer, revealing the layer of white underneath. This will simulate the white border of the paper. Select a grey colour and paint on the mask on the white border sections to make the transition subtler.

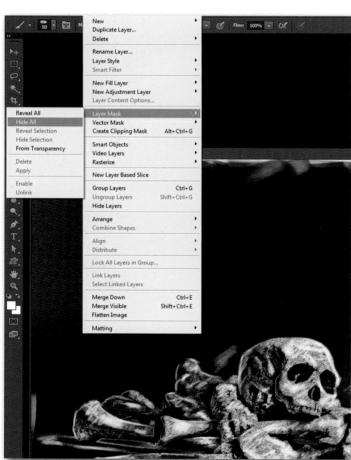

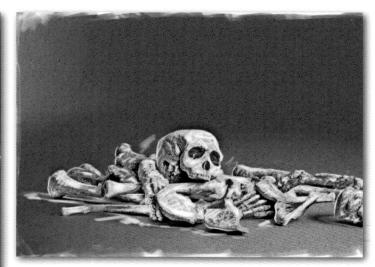

Step 12 \triangle \triangleright

Press Shift + Ctrl + Alt + E to make another copymerged version of the image. Set the blending mode to *Multiply* to make the image darker, then go to *Layer>Layer Mask >Hide All*. Use the *Chalk Brush* to reveal parts of the darker version of the image to simulate dark charcoal smears.

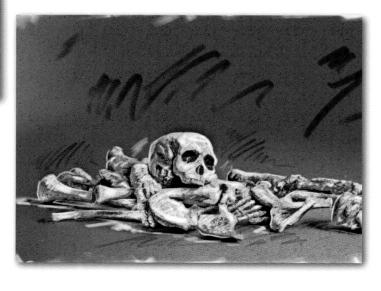

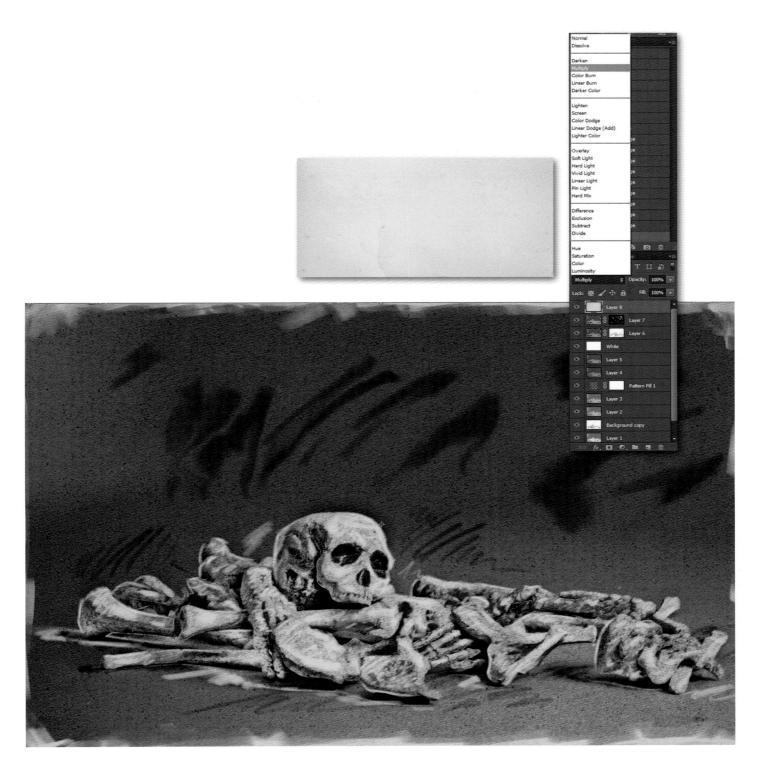

 \triangle Step 13 As a finishing touch, copy and paste in an old paper texture (top) and set the blending mode to *Multiply*.

Highlights, Glows and Shadows

One of the advantages of digital over traditional art is that it allows you to create effects like highlights and glows with minimal effort. You can also produce shadow layers, where changing the base colours allows for great versatility.

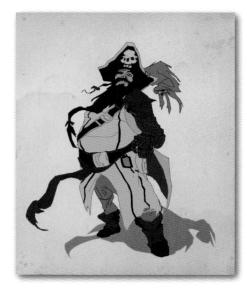

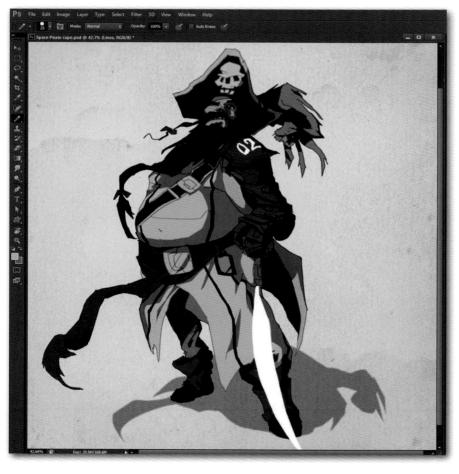

Step 1

After laying out your base colours for the image, create a new 'Clipping Mask' layer and set the blending mode to *Linear Burn* at 65% opacity. (The *Linear Burn* blending mode allows more colour to show through than the *Multiply* blending mode, which darkens colours that are applied to the layer.) You can use whatever colour you like to apply shading to this layer, but I would recommend *R*:137, *G*:118, *B*:118, as this combination works well with any colour underneath it.

Step 2

My preference is for cel shading (the name harks back to an era when cartoons were drawn on animation cels). I use a hard-edged brush or the *Pencil Tool*, alongside the *Lasso Tool*, to apply shading. But any type of shading will work well on the 'Linear Burn' layer. If you prefer a softer style of shading, you can use the *Linear* and *Radial Gradient Tools* and an airbrush. You can create a nice effect by combining these two styles of shading.

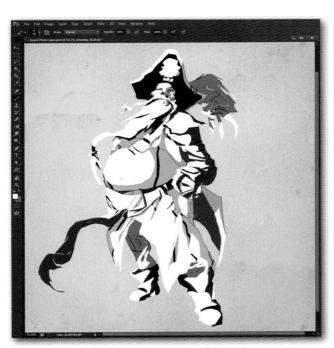

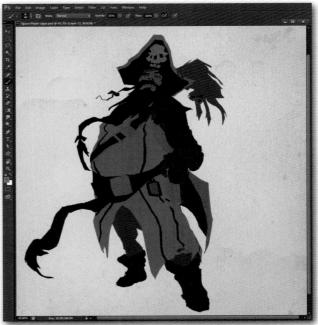

△ Step 3

Another approach to shading is to make your base colours darker and apply highlights to your work. This means you won't have to add highlights at a later stage. Create an *Overlay* layer over your base colours and line work and use pure white to add highlights; this will brighten the colours beneath.

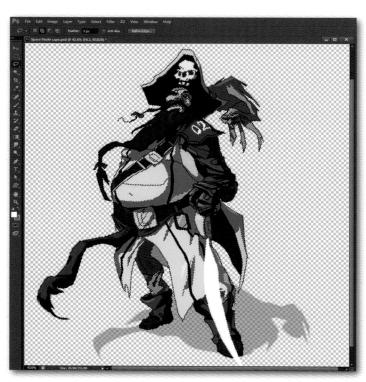

$\lhd \, riangledown$ Step 4

Highlights always look more convincing when the light bleeds out slightly from the edge of the shadows, much as it does in real life. Fortunately, Photoshop allows you to select *Luminosity* (the bright parts of an image) with one simple action: Ctrl + Alt + 2. Press Shift + Ctrl + C, followed by Shift + Ctrl + V, to paste in a copy of the light parts of this image. Now change the blending mode to *Overlay* and apply a *Gaussian Blur* to make the light scatter slightly over the shadows.

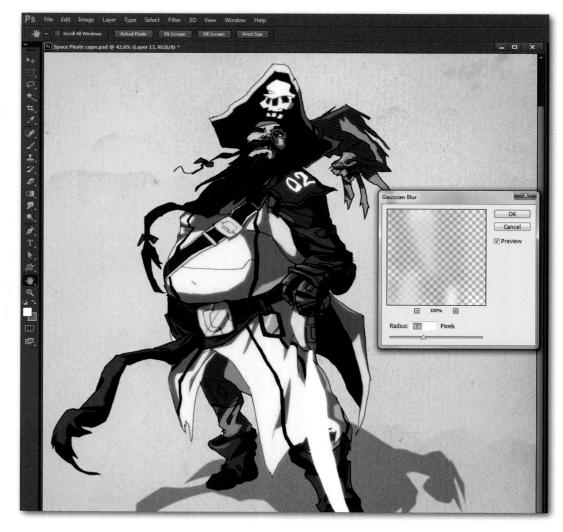

When an object glows, the centre is pure white. It's only as the glow scatters from the centre that we notice any colour. Draw the elements you want to glow in pure white and on their own layer. Then create a layer underneath and set its blending mode to *Screen*, so that any light you render on the layer will be translucent. Select the *Radial Gradient Tool*, setting 'Foreground to Transparent' and 25% opacity, and choose a highly saturated version of the colour you want for the glow. Drag the *Gradient Tool* outwards from the white centre and you will instantly have your simulated glow.

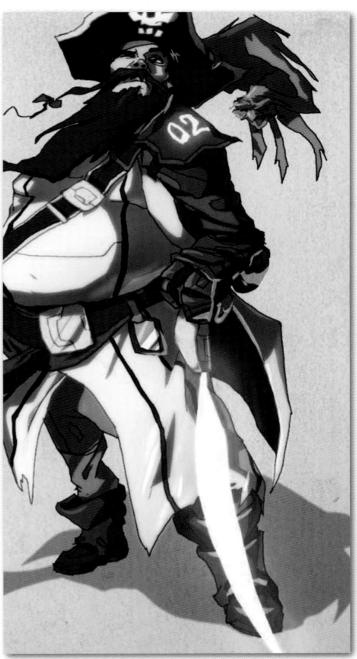

△ Step 6

To add a more opaque glow (particularly effective for rim lighting) create a layer set to Linear Dodge mode and apply your lighting with a low saturation version of the glow colour. For example, use a soft pink to reflect a red light.

Step 7
 To make the light effects more intense, simply double up on the 'Linear Dodge' layers to show various levels of light.

Step 8 ⊳

One way to make your shadows look richer is to create a 'Clipping Mask' layer immediately over your base colours and beneath your 'Shading/ Highlight' layers. Apply tints of colour with the *Radial Gradient Tool*, using warmer tones for foreground elements and cooler shades for the background.

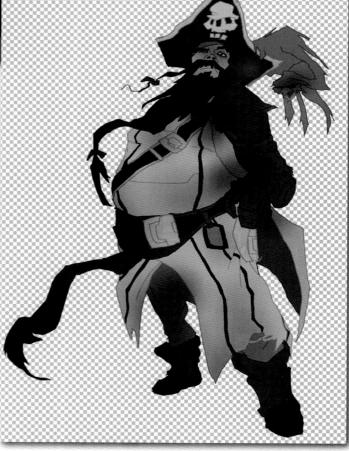

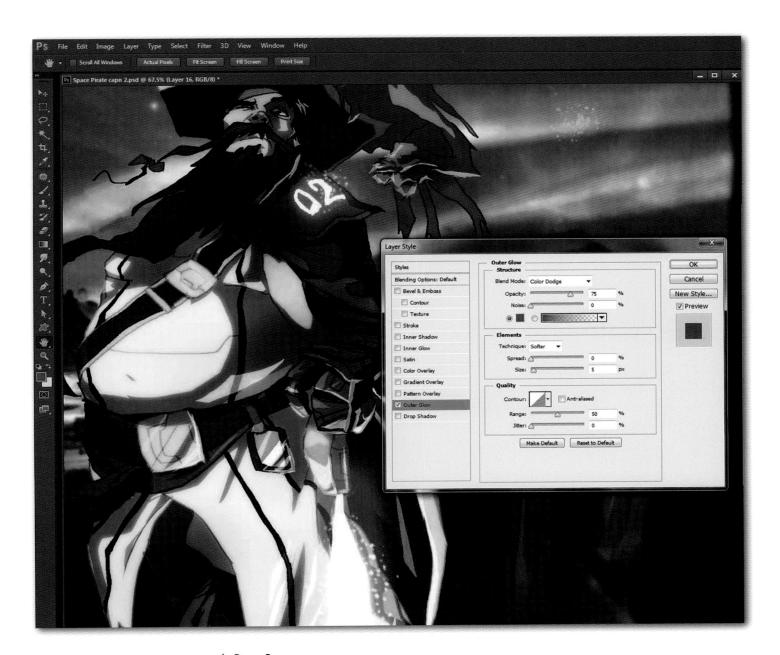

To create smaller particle glows, use a white colour speckle brush to paint in the centre of your particle lights. Double-click on the layer in the 'Layers' palette to bring up the 'Layer Style' menu. In the left-hand column, click on *Outer Glow* to access its options. In the centre panel, set as follows: *Blend Mode, Color Dodge; Opacity, 75%*. Choose an appropriate colour for your glow. Anything you paint on this layer will now automatically have a glow around it.

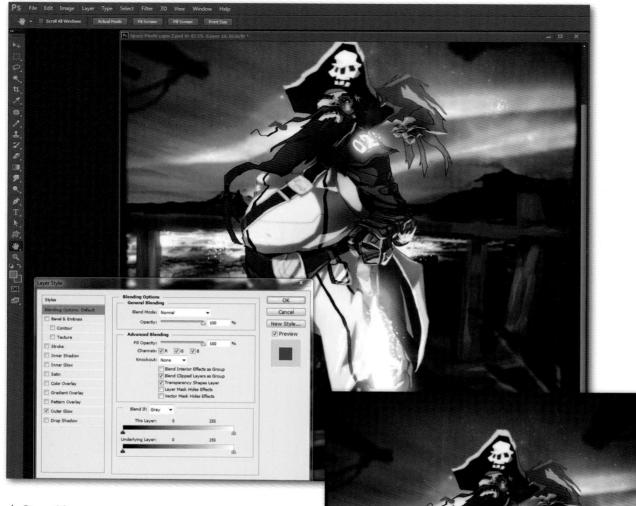

One of the advantages of using a 'Colour Dodge' layer for multiple glows is that you can edit it at any time. As you've applied a layer style, you can instantly effect changes to everything on the layer. For example, if you want to change the colour, intensity or distribution of the glows, just double-click on the layer and edit the options from the 'Layer Style' dialog box. Here, by switching the colour in the layer style to yellow and adjusting the hue (via *Hue/Saturation*) of the 'Glow' layer below, I've changed the pirate's energy sword from red to yellow in just a few clicks.

Step 11 \triangle \triangleright

When you've finished rendering the rest of your image, add an 'Overlay' layer and use the *Radial Gradient Tool* to add various soft glows to tint the environment and the character. For example, add a hint of red to the pirate's face, illuminate his shoulder pads, and bring the glows out further from the aurora borealis effect in the background to make them more colourful and dramatic.

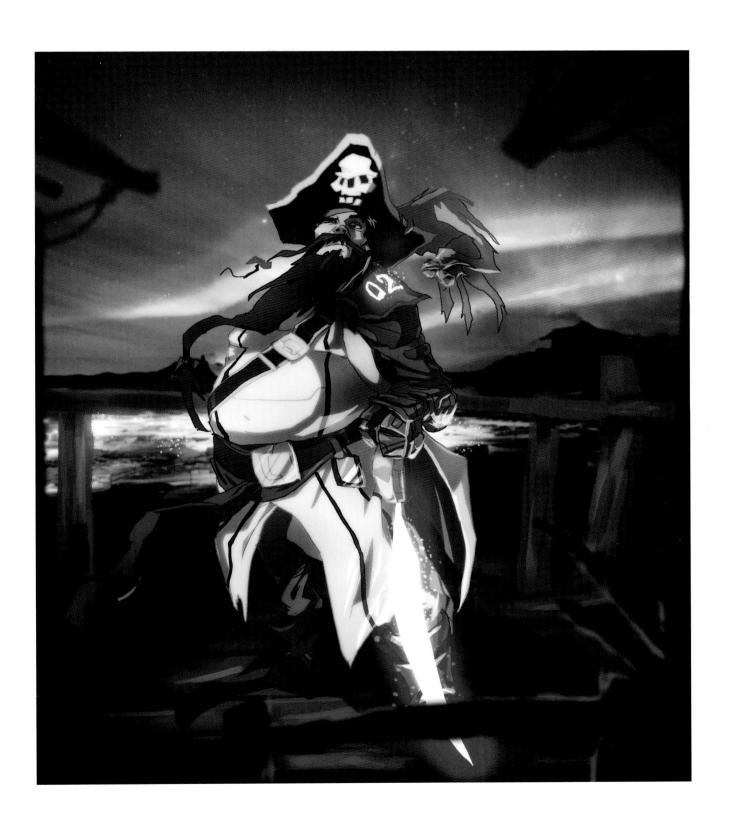

Drawing From Reference

For this exercise I was inspired by a photograph of my daughter rummaging among my things and I used the picture as a starting point for my digital art. Ignore the detractors – any artist worth their salt will tell you the value of drawing from reference. The key is not to be a slave to it, but to be inspired by it.

√ Step 1

Open up your reference photo alongside your new image. Use a light blue brush to draw in your roughs based on the photograph.

Step 2 ▷

Lower the opacity of the layer to around 45%. Create a new layer called 'Lines' and use a black brush to draw your finished line work.

Ctrl + J to duplicate the 'Lines' layer and name this new layer 'Flats'. Press G to select the *Paint Bucket Tool* and use it to fill in the areas of flat colour. Don't feel you have to be restricted by the colours in your photograph: it's often much better to choose new colours to suit the mood of your illustration.

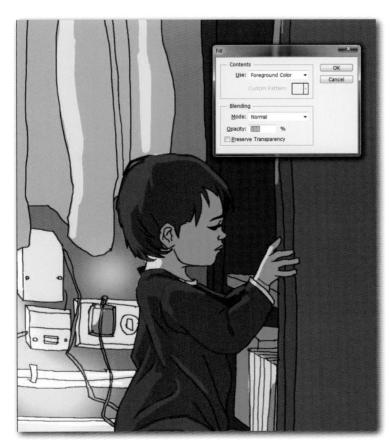

\triangle Step 4

Create a new layer, set it to *Overlay* and name it 'Highlights'. Use the *Pencil Tool* with a pure white colour to render the highlights on the child, the curtain, the shelves and the shoes. Switch to a soft airbrush with the same white colour to paint in the highlights on the walls and floor.

Step 5

I decided to change the colour of the lines from black to red to make them fit better with the overall colour scheme of the picture. To do this, lock the transparent pixels on the 'Lines' layer by clicking on the small chessboard icon in the 'Layers' palette. Press Shift + Backspace and select 'Use Foreground Color' to fill the lines with a dark red.

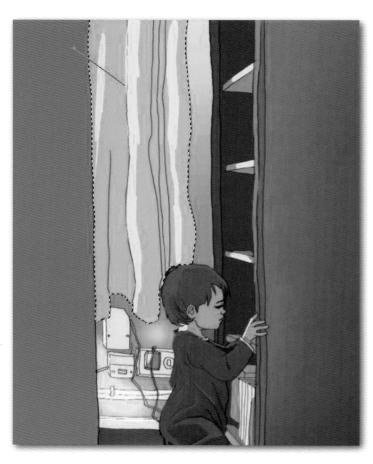

Step 6

Create a new layer called 'Colour Tints'. Use the Magic Wand Tool (press W) to select an area on the 'Flats' layer, then switch to the 'Colour Tints' layer. Select the Linear Gradient Tool (press Shift + G) and use a variety of lighter and darker colours to apply some smooth shading to the image.

Step 7 ⊳

Time to add a paint texture. If you're just using Photoshop, you can use an existing photo of a paint texture (there are numerous free textures online), but it is much more effective to make your own in Corel Painter. In this program, use the *Paint Bucket* to fill the canvas with a dark base colour, then select the *Oil Bristle Brush* and start to use lighter variations of that colour across the canvas. Try to use large brushstrokes to make sure they are obvious. Use the *Just Add Water* blender to soften any edges where the brushwork is too noticeable and could detract from the artwork.

√ Step 8

Open the paint texture file in Photoshop and go to *Image>Adjust>Hue/*Saturation. Move the Saturation slider all the way to the left to desaturate the image. Copy and paste the paint texture on top of your artwork and set the 'Layers' blending mode to Overlay.

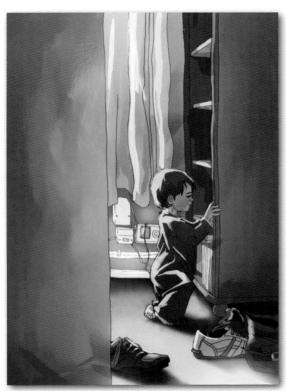

\triangle Step 9

Create a new layer set to *Linear Dodge* and make a selection of the highlights by Ctrlclicking on them. Then use a light yellow colour to paint in and boost the highlights on the new layer.

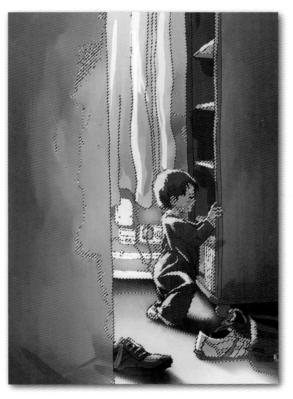

\triangle Step 10

To simulate the way in which light scatters and to boost the richness of the light, press Ctrl + Alt + 2. This makes a selection of the *Luminosity* (all the light areas of the image). Press Shift + Ctrl + C, then Shift + Ctrl + V to paste a merged version of the light areas over your artwork. Set the layer to *Overlay*. Click on *Filter>Blur>Gaussian Blur* and use a blur of around 7 pixels.

 \triangle Step 11

As a finishing touch, introduce a patterned effect to the curtains. Use the *Magic Wand Tool* to select the curtains and paste a patterned texture into the area. Choose *Edit>Paste Into* and change the blending mode to *Soft Light* at 79% opacity.

In the final image you can see how the added patterns and textures combine with the blended highlights to create a warm, homely composition.

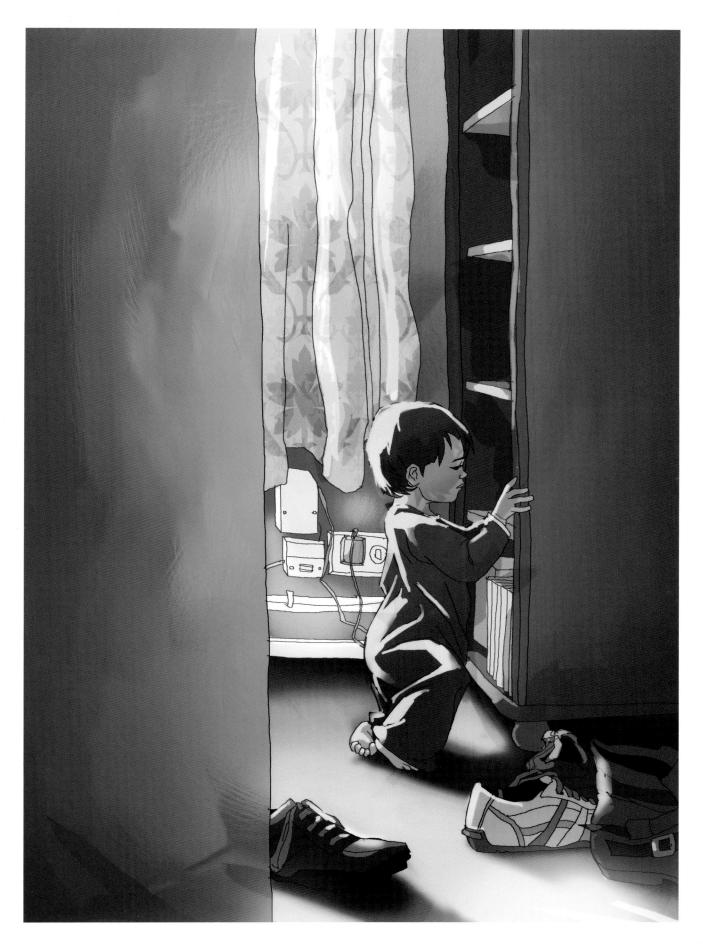

Creating Line Art From a Photo

Hand-drawing architectural subjects such as buildings in a city street can be time-consuming and requires a great deal of skill and patience. It is much easier to get Photoshop to create the line work for you from a photograph.

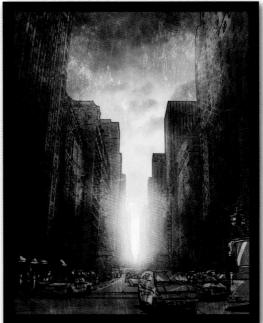

Step 1 Open your photo and press Ctrl + J to duplicate it. Now press Ctrl + U to access the 'Hue/Saturation' dialog box and move the Saturation slider to the extreme left to desaturate the image.

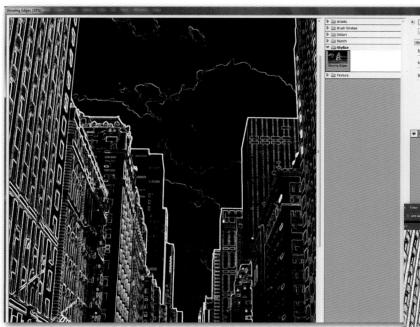

√ Step 2

Go to Filter>Filter Gallery>Stylize and select Glowing Edges.

Experiment with the slider settings until you get an effect that looks like reversed-out comic-book line art.

Step 3 ⊳

Invert the layer by pressing Ctrl + I, then make the whites lighter and the blacks darker by adding a 'Levels Adjustment' layer. Edit this layer in the properties panel that opens up. Move the white triangle slider slightly to the left and the black one slightly to the right. This will eliminate a lot of the grey noise.

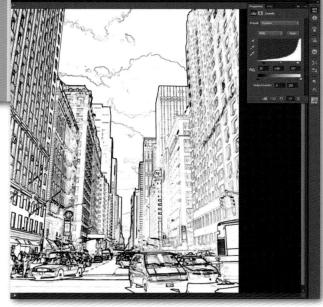

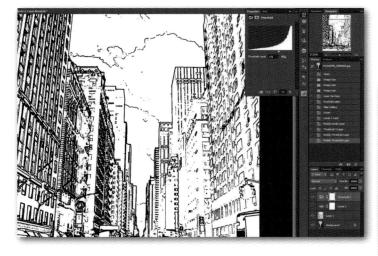

△ Step 4

Back in the 'Layers' palette, add a 'Threshold Adjustment' layer to tweak the balance between black and white even further. Lower the opacity of this layer to around 38% (depending on your image).

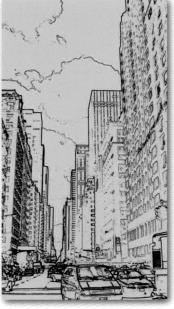

√ Step 5

Press Shift + Ctrl + Alt + E to make a stamp from all the visible layers and set this layer to *Multiply*. Hide the old layers. Create a new layer underneath the 'Stamp' layer so that you can paint the background to the image on this. Press Shift + Backspace and select 'Use Foreground Color' to fill it with yellow.

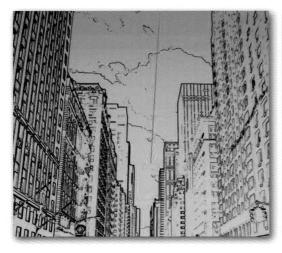

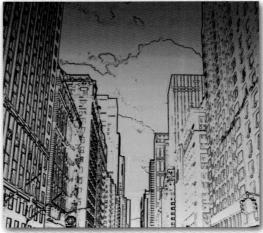

Step 6
Press G to select the Linear Gradient Tool and set to 25% opacity, Foreground to Transparent. Begin to make the sky darker, starting at the top. First apply orange gradients, followed by red, then purple.

Step 7 ⊳

Add a layer mask to the 'Line Art' layer by clicking on the small circle in the square icon in the 'Layers' palette. Select a brush and paint out the detail of the clouds from the sky.

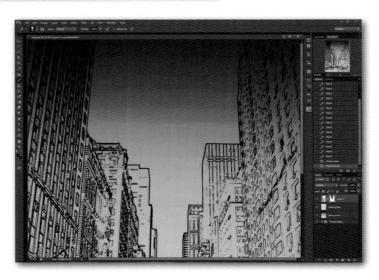

Step 8 ▷

Find a reference photo of a sunset. Copy and paste this into your artwork over the background layer and set its blending mode to *Overlay*. Free transform it to fit your image. Find another photo of clouds that suits your image and repeat the process. Press E to select an *Airbrush Eraser* and erase any obvious joins between the two photos.

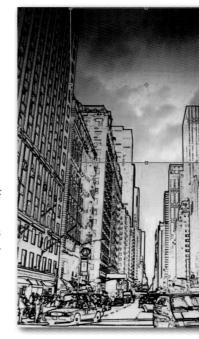

Step 9 ▷

Now you are going to paint in the road. Create a new layer over the background and clouds. Use the Square Marquee Tool (press M) to select the area of road and fill it with dark grey by pressing Shift + Backspace. Switch to the Radial Gradient to make the first part of the road slightly lighter where the sun is hitting it.

\triangle Step 10

Create a new layer for painting the buildings. Select the Polygonal Lasso Tool (press Shift + L) to trace round the outlines of the buildings, then fill them with a cool brown colour.

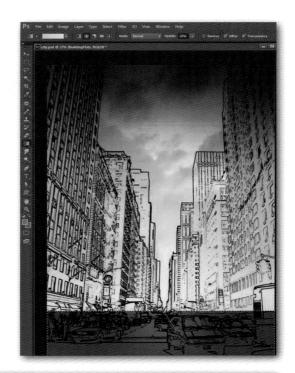

\triangle Step 11

Lock the opacity of the buildings layer by clicking on the padlock in the 'Layers' palette. Now select the Linear Gradient Tool and apply dark blue gradients to the lower part of the buildings where shadows fall on the street.

Step 12 ⊳

Add a 'Vibrance' adjustment layer and increase the *Vibrance* and *Saturation* sliders to the maximum (100) to make the colours more vibrant. Add a new clipping mask layer called 'Building Highlights' and set the blending mode to *Overlay*. Paint with pure white to suggest areas where the sun may be striking the buildings as it sets.

Step 14 ⊳

Select the *Luminosity* of the image by pressing Ctrl + Alt + 2, then press Shift + Ctrl + C followed by Shift + Ctrl+ V to paste it in on a new layer above. Go to *Filter>Blur > Gaussian Blur* and apply a radius of approximately 38 pixels to make the sunlight scatter more widely.

Create a new layer to add glare to the image. Set the blending mode to *Screen* and use a series of light yellow radial gradients to simulate where the sun's rays are flooding the buildings in the background.

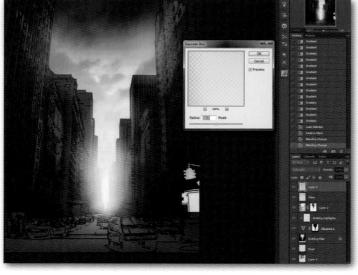

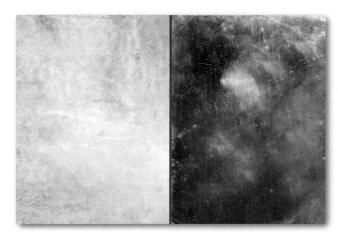

Now add some grungy texture to your image. You can download lots of great textures for free (see page 128). For variety, use at least two textures over your image and set both their blending modes to *Overlay*. Lower the opacity so that both are below 50%. This will ensure that they do not overpower the image.

Step 16 ⊳

Find a scratches texture image and copy it. Go back to your original image and click on *Channels* (next to the 'Layers' tab). Click on 'Create New Channel' in the bottom of the 'Channels' palette. Paste in the scratches to create a new alpha channel, then Ctrl-click the new alpha channel's thumbnail to make a selection of the scratches.

$\mathrel{ riangle} \bigtriangleup$ Step 17

Click back to the 'Layers' tab and create a new layer called 'Scratches' at the top of the layer stack. Fill the selection with pure white, set the layer's blending mode to *Overlay* and lower the opacity to around 55%.

Now add a paint texture to the image; set it to *Overlay* at 55%. (See pages 108–9 for how to create paint textures in Corel Painter.)

Step 19 ⊳

As a finishing touch, add a border. Go to *Image>Canvas Size* and, when the 'Canvas Size' dialog box appears, check the 'Relative' box and set the new size by adding 2 cm to the width and height. Click OK.

Step 20

Create a new layer in order to add a black border. Ctrl-click the background layer in the 'Layers' palette to select it, then invert the selection by pressing Shift + Ctrl + I. Select a pure black and fill the black border layer using Shift + Backspace.

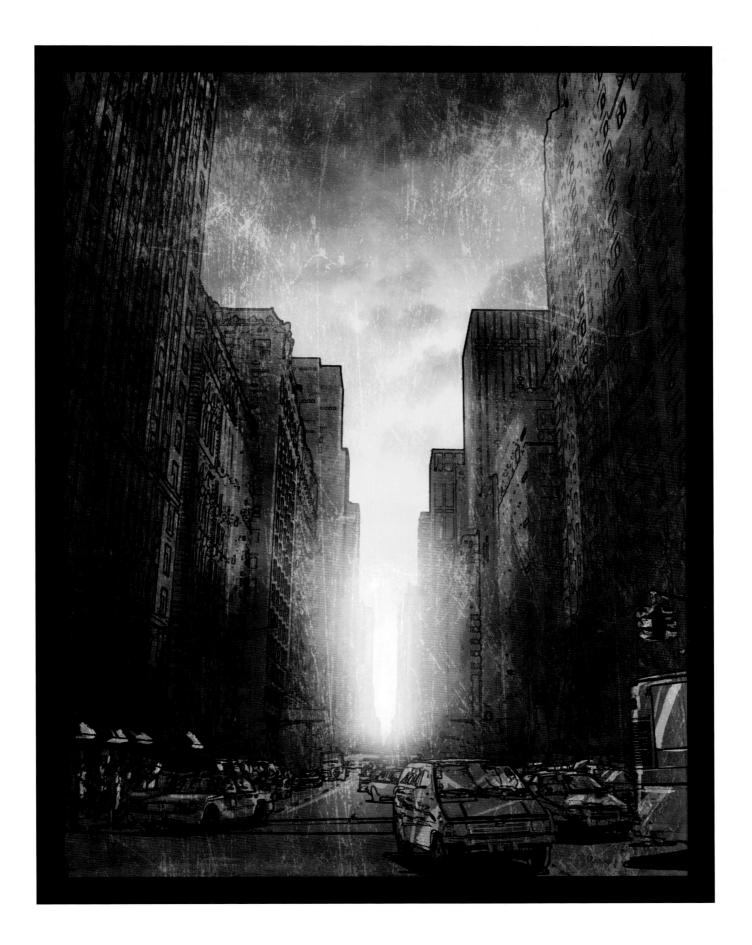

Digital Distress Effects

With digital art, you can create images containing distress effects that mimic screen grabs from television monitors.

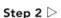

Duplicate the image by pressing Ctrl + J, then press Ctrl + U to access the 'Hue/ Saturation' dialog box. Make this layer red by ticking the 'Colorize' box, increasing the Saturation slider to 100 and adjusting the Hue slider to red. Set the layer's blending mode to Exclusion.

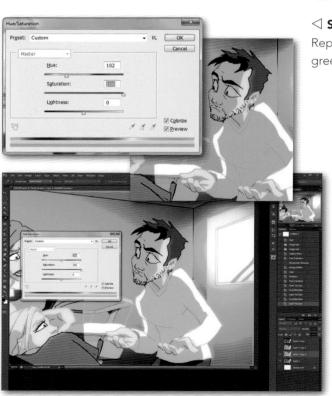

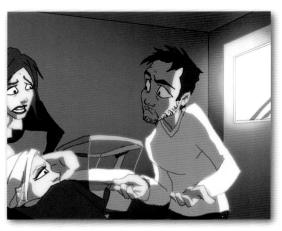

√ Step 1

Start by opening a new file set to the 4:3 traditional aspect ratio for television (search Photoshop's film and video default settings and presets for options). Paste in the image you want to use as a base for your fake VHS screen grab (it helps if you use a high-contrast image).

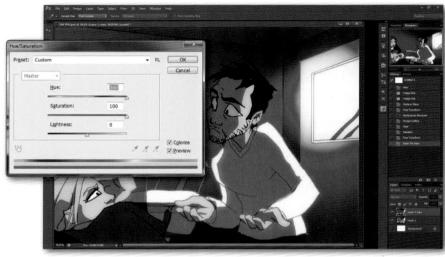

√ Step 3

Repeat the duplication process twice more, colouring one of the layers green and the other cyan. Set both blending modes to *Exclusion*.

△ Step 4

Select the *Move Tool* (press V) and press the arrow keys to nudge the red layer a few pixels to the left and the green layer a few pixels to the right. This will replicate the distorting effect that used to occur when old TVs misfired slightly.

Step 5 ▷

Make another copy of the original layer and move it to the top of the layer stack. Lower the opacity of this layer to around 80% so that the *Exclusion* layers start to show through.

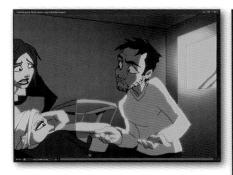

√ Step 7

5

Next go to the Filter Gallery and select Brush Strokes>Spatter. Set as follows: Spray Radius, 10; Smoothness, 5. Press Ctrl + F to run this filter a second time. Then go to Filter>Blur >Blur (not Gaussian Blur). Lower the opacity of the layer to between 5% and 20%, depending on your image.

△ Step 6

To add a grainy quality, create a new overlay layer. Check the box that says 'Fill with overlay-neutral colour (50% grey)' and press OK. Go to Filter >Noise >Add Noise and set as follows: Amount, 400%; Distribution, Gaussian. Check the 'Monochromatic' box.

To produce the scan-line effect, you first need to create a scan-line pattern, so open a new document with a width of 6 pixels, a height of 12 pixels and a resolution of 72. Double-click on the background layer in the 'Layers' palette to make the background an active layer. Erase everything on the layer so that you just have transparent pixels.

Step 9 ▷

Go to View>New Guide and set as follows: Orientation, Horizontal; Position, 50%. Click OK.

Press M to select the *Square Marquee Tool* and drag a selection over the top half of the image. Use a brush to fill the top half of the image with black. Go to *Edit >Define Pattern*, name your new pattern and click OK.

Step 11 ⊳

Click on the black-and-white circle icon in the 'Layers' palette and select *Pattern* to create a 'Pattern Fill' layer. Select your new scan-line pattern from the drop-down menu and enlarge the scale of the pattern so that it fits your image. Check the layer's blending mode to *Overlay* and lower the opacity to 18%.

Hide the visibility of the scan lines for now by clicking on the eyeball icon in the 'Layers' palette. Select the Square Marquee Tool and use it to create a long, thin horizontal selection across the image. Press Shift + Ctrl + C, followed by Shift + Ctrl + V, to paste a copy-merged version of the selection. Press V to access the Move Tool and use the arrow keys to nudge the selection left or right (depending on what suits your image best) so that the band of the image is skewed. Repeat this process once or twice, so that you have created several of these errors on the image.

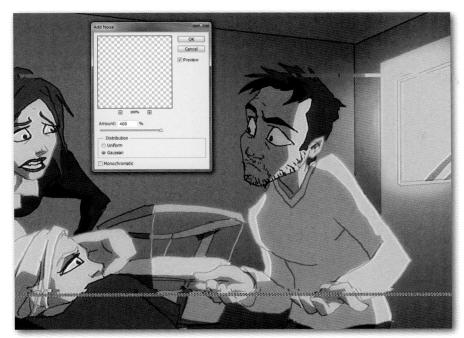

To replicate the noise corruption effects, follow the previous step to create a copy-merged version. However, once you have done this, don't move it as before. Instead go to Filter>Noise >Add Noise and use the following settings: Amount, 400%; Distribution, Gaussian. Leave 'Monochromatic' unchecked.

∇ Step 14

Repeat Step 12 a few times to produce the desired amount of distortion to your image. Bring back the scan lines. The art is now finished.

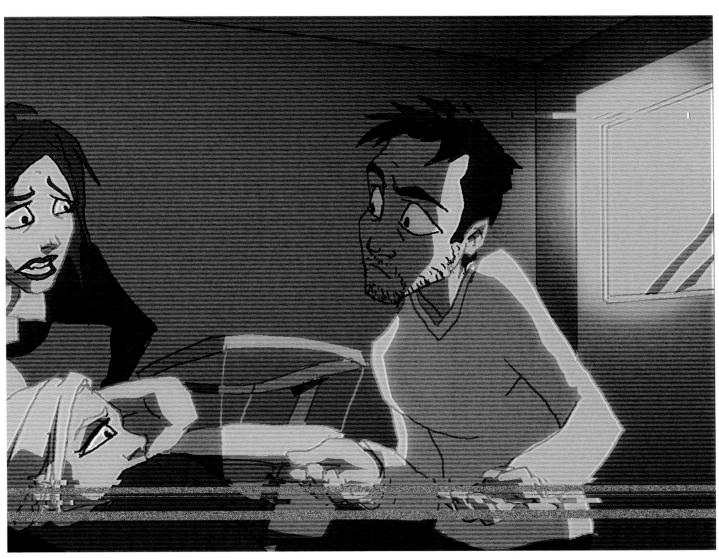

Retro Pixel Art

This exercise shows you how to make your own retro-inspired computer game art in Photoshop.

\triangle Step 2

For hard-edged pixels, you will also need to change the way Photoshop resizes things. Go to Edit>Preferences>General and set thus: Image Interpolation, Nearest Neighbor (preserve hard edges).

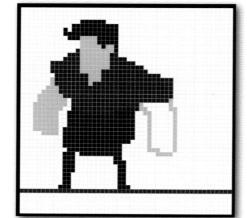

Step 3 ▷

Select the *Pencil Tool* (Shift + B) and reduce the size of the pencil to
1 pixel; everything

you draw in this exercise will require you to remain at this size. Draw the outline of your character and use the *Paint Bucket Tool* (press G) to fill in the areas.

\triangle Step 1

Create a new document sized at 50 x 50 pixels. Go to View>Show>Pixel Grid; this brings forward a visual grid. However, there is a chance that it won't have been set up to the specifications you require, so go to Edit>Preferences and in the 'Grid Section' dialog box select the following: Color, Light Gray; Gridline Every, 1 Pixels; Style, Lines; Subdivisions, 1. Go to View> Snap To and uncheck 'Grid'.

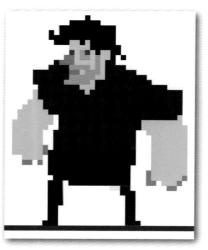

\triangle Step 4

If you've not lined up an area correctly, use the *Polygonal Lasso Tool* to select, then access the *Move Tool* (press V) and nudge the element you want to move with the arrow keys. You can press Ctrl + H to hide or reveal the grid at any time.

Step 5

As we've not allowed ourselves many pixels to work with in this document, I haven't used outlines to draw the character. Instead, I've used shape, colour and a small amount of shading.

\triangle Step 6

Although I have given my character a bit of background here, my image is not telling much of a story. So I've created a document, with pixel dimensions 239 x 179, and moved the character into it by clicking on him in the 'Layers' palette and dragging him into the new document.

Step 7 \triangleright

I want to show a story where the character has accidentally stumbled into a video game world, so have created a new layer and filled it with a sky colour. I've created another layer to start painting the scenery and added a further layer at the top of the layers stack. I've used the Square Marquee Tool to select two rectangular areas and filled these with black to simulate the widescreen border effect that used to feature in old computer games.

\triangle Step 8

All the background elements have been drawn freehand with the *Pencil Tool*. I've used warm colours in the foreground and cooler colours in the background. If any time you want to recolour an element, use the *Paint Bucket Tool*, ensuring that 'Anti-aliased' is unchecked in the *Options Bar*.

△ Step 9

Alter the composition a little by Shift-clicking all the layers and nudging everything up with the *Move Tool.* Use the *Square Marquee Tool* to select the black borders and press Ctrl + T to resize them.

Step 10 ▷

Make the colours richer by adding a new layer with the blending mode set to *Overlay*. Select the *Linear Gradient Tool* (press G) to apply cool, dark blues to the top of the image and warm, dark browns to the bottom.

Now I want to add scme text along the bottom border to emulate the verbal commands in old computer games. The document is currently too small, so go to Image>Image Size and increase the document size (in this case I increased it from 2.02 cm to 8.08 cm wide).

Step 12 ⊳

Press T to select the *Type Tool* and click and drag an area for type (clicking and dragging will align the text you want to add). Using an appropriate retro pixel font (there are many great free fonts online) add the text 'Give, Open, Close', then commit the type.

Press Ctrl + J to duplicate the type layer, then use the *Move Tool* (press V) to nudge the text into position. Press T and click on the duplicated layer to change the words to 'Pick Up, Look At, Talk To'. Repeat the process to add the final column of text.

Duplicate this layer, then press Ctrl + T and right-click over the bounding box to select 'Rotate 90° CW.'

\triangle Step 14

As a finishing touch, add the cursor that controls the game. Do this by creating a new layer, making a vertical rectangle selection with the *Square Marquee Tool* and filling it with white.

Step 16 \triangleright

With the Square Marquee Tool, select the area where the two lines overlap. Hit Backspace to clear the selection on the two layers and merge them by pressing Ctrl + E.

Free Downloads

http://labs.adobe.com/downloads/pixelbenderplugin.html The Pixel Blender Oil Filter plugin

http://russellbrown.com/scripts.html
Tim Shelbourne and Russell Brown's
Watercolour Assistant panel

http://www.richardrosenman.com/software/downloads/ Richard Rosenman's free filters and plugins

http://lostandtaken.com High-resolution textures

Index

Adobe Illustrator 11, 21 Adobe Photoshop 8, 9, 10, 21, 24

aliased pixels 22–3 ambient light 53 angles 46–7, 51

Brush Tool 24-5

Background Eraser Tool 31 blending modes 44–5 blurs 38–9 bodies 58–9 bristle brushes 26–7

camera angles 46–7 chalk effect 92–7 charcoal effect 92–7 CMYK 6, 7 colour editing 23 colour modes 6–7 colour moods 54–5 colour selection 16–17 component effects 45

composition 46–7, 64–5 contrast 45, 48, 60–1 Corel Painter 10, 20 Crop Tools 14–15 Custom Shape Tool 32–3

darkening effects 44 digital art programs 20–1 distress effects 120–3 downloads 128 DPI 7 drawing from reference 106–11

elements 60–1 Eraser Tool 30–1 exaggerated poses 63 exporting 18–19

faces 56–7
Field Blur 39
filters 40–1
Flash 11
focus 49
fonts 34–5
formats 18–19
free downloads 128
Free Transform Tool 36–7

Gaussian Blur 38–9

GIFs 19 glows 98–105

highlights 98–105 horizontal proportions 59

inversion effects 45 Iris Blur 39

JPEGs 18

Lasso Tools 13 layer masks 42–3 light 52–3 lightening effects 44 line art from photos 112–19 local colour 55

Magic Eraser Tool 31
Magic Wand Tool 14
Marquee Tools 12
Mixer Brush 27
modifying 37
moods 54–5
Motion Blur 38
Move Tool 12

oil paint effect 72–7 overlap 50

Pen Tool 28–9 Pencil Tool 22–3 perspective 50–1 photo retouching 66–71 photos to line art 112–19 pixel-based artwork 10, 22–3 PNGs 19 pointers 47

poses 62–3 PPI 7 proportions 56–9 PSDs 18

Radial Blur 38 radiosity 52 reflected light 52 repetition 51 resizing 36 retouching photos 66–71 retro pixel art 124–7

RGB 6, 7 rotating 37 rule of thirds 64–5

saving 18–19 shadows 98–105 silhouettes 62 silkscreen print effect 86–91 size resolution 7 Sketchbook Pro 9, 10, 20

TIFFs 19 Tilt-Shift Blur 39 Type Tool 34–5

vector-based artwork 11 vertical proportions 58

watercolour cloning 78–85 workspaces 8–9